The Isenheim Altarpiece

Text by Georg Scheja

Photographs by Bert Koch

Harry N. Abrams, Inc. *Publishers* New York

To my wife Sagitta

Dorothy L. Sayers and Barbara Reynolds translation of Dante's *The Divine Comedy* used by permission of Penguin Books Ltd.

Translated from German by
Robert Erich Wolf

Frontispiece: The Virgin of the Annunciation

Contents

Preface and Acknowledgements

This introduction to the Isenheim Altarpiece is based on scholarly research that I have been reporting in lectures and papers for some years now. It would go far beyond the intention of this volume to present all the results of that research in detail. Also, with a wider audience in mind, quotations from foreign languages have been given for the most part in translation, and references to the scholarly literature have been restricted to a minimum. In order to make the reader aware of the many-sided complexity of the scientific problems posed by the Isenheim Altarpiece, other writers' analyses of both its form and its content have been gone into at rather greater length than is usual wherever they seemed essential to an understanding of the whole. I believe, however, that in my own attempt to unearth the special cultural and historical factors which led to the creation of one of the most impressive works of all art, I have established bases that are sufficiently solid and convincing in themselves.

My publishers and I owe special thanks to the administration of the Musée d'Unterlinden in Colmar and to its Director, M. Pierre Schmitt, particularly for their courteous authorization for the making of new color photographs of details of the altarpiece, photographs which should provide the reader with a deeper understanding of this masterwork and thus stimulate him someday to become acquainted at first hand with the original.

Introduction

As a precautionary measure during World War I the Isenheim Altarpiece was removed from the Unterlinden Museum in Colmar, its home then as now, and bundled off to a safer place. In those more innocent times, before civilian centers too became fair targets, this meant Munich. There the work was restored and, toward the end of the war and for a short time afterward, exhibited in the Alte Pinakothek.

What came of this was the passionate rediscovery of Matthias Grünewald, an artist virtually forgotten for centuries, and the rediscovery was so much more a revelation, aroused so much greater enthusiasm, for having been made on his chief opus. Certainly the painter known as Grünewald was not exactly unknown to art experts and scholars. No less than Jacob Burckhardt, as far back as 1847, had written an appreciation of him in Franz Kugler's *Handbuch der Geschichte der Malerei*, which had stimulated research into this obscure personality, and by 1914 the basic facts were known. Then too the writings of Joris-Karl Huysmans, especially the novel *Là-Bas* in 1891, had helped to focus attention on the unique profundity of Grünewald's art.

Yet it was only when a worldwide catastrophe provided the occasion for many more people to see the altarpiece itself at firsthand that there came about a deeper contact with the art of Grünewald which struck many persons as providential or even fateful. Some sort of historical providence indeed seemed to be at work: at the precise moment when everything men did and thought in politics and the realm of intellect was in need of new bases, new criteria, the long-accepted constellation of great interpreters of human existence was suddenly and radically altered by the introduction of an unknown star, a nova of imposing magnitude. Expressionism, a movement that was fundamentally German, could enroll Grünewald as chief witness for the defense, and he seemed in fact to have some uncanny relevance to the crisis that faced the world at that moment in history. His courage in revealing that what remains intact through disaster and grief is always the human essence came as a voice raised in confirmation of the Expressionists' thesis, and at the time it was a voice crying hope in the wilderness.

Our present generation views things more soberly, with a

dose of skepticism, but has not lost its feeling for Grünewald's art, a feeling which, down to its last detail, is ineradicable, What emanates from that art is not something that can be fitted into the easy and self-assured plane on which we live today. It remains, instead, rooted in each man's personal experience of man's fate.

For the art historian, Matthias Grünewald is not one of those everyday historical problems easy to talk about but, to the contrary, an isolated and lonely exception whose connection with history is unique and even difficult to grasp. Whatever the angle from which one seeks to approach him, whether through his biography or through the basic influences on his art, he takes refuge in anonymity. Even the name with all its poetic associations of green forests that history has fastened on him, and which scholars have therefore had to continue to use, is, in fact, an error and a disguise. But his right name or, more properly, names—Mathis Gothart Nithart—are in no way more revealing, because we are not sure which was his original name and why he should have annexed another to it. From what the most strenuous efforts of researchers have been able to uncover about the facts of his life—at best a few random documents concerning his activity as architect, court painter, and hydraulic technician at the Archbishop's court in Mainz and about his lonely death in the service of the city of Halle—we gather a bit about the everyday life of the man but almost nothing of the luminous personality that expresses itself in his art.[1]

Similarly, we are anything but clear about his artistic achievement, intimately human as it is in its origins and its spiritual backgrounds. So true is this of the Isenheim Altarpiece in particular that discussion and debate about it show no signs of letting up. The present essay aims to cast new light on the formal composition of the altarpiece and on the cultural background which is the key to its symbolic content, and it is proposed that these were the products of the peculiar constellation of German and Italian theological conceptions prevalent in the monastery at Isenheim where, in Grünewald's time, the preceptors who commissioned this altarpiece from him were, in fact, themselves from Italy.

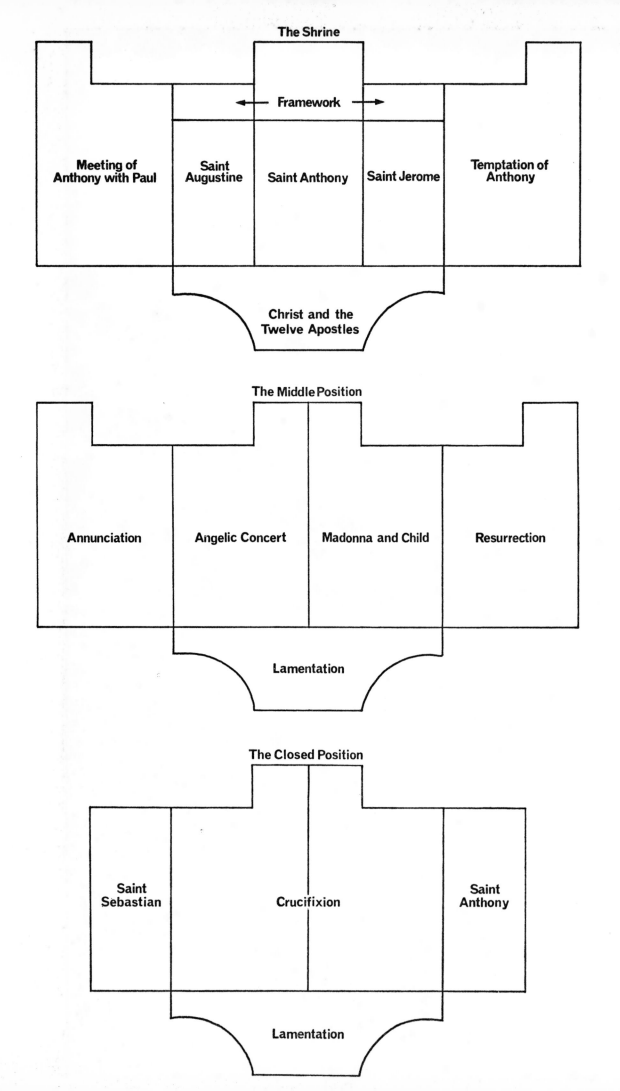

The Shrine

← **Framework** →

Meeting of Anthony with Paul — Saint Augustine — Saint Anthony — Saint Jerome — Temptation of Anthony

Christ and the Twelve Apostles

The Middle Position

Annunciation — Angelic Concert — Madonna and Child — Resurrection

Lamentation

The Closed Position

Saint Sebastian — Crucifixion — Saint Anthony

Lamentation

The closed position: The Crucifixion

Background

The Isenheim Altarpiece originally stood on the high altar of the abbey church of the Anthonites in the tiny Alsatian hamlet of Isenheim. There, in Isenheim, in the first years of the sixteenth century, a number of especially propitious circumstances came together to bring about the creation of the most extraordinary altar painting of German art at the close of the Middle Ages.

The Anthonites were a hospital order which from the twelfth century on had spread throughout the West from the mother house of Saint-Antoine-en-Viennois in the Dauphiné region of south-central France. Saint-Antoine could boast of owning the miracle-working relics of Saint Anthony the Great, the Egyptian anchorite who in the fourth century founded the Thebaids, the communities of hermits in the desert. In the eleventh century the relics had been transferred from Constantinople to a small chapel in France, at Saint-Didier-de-la-Motte, and this led to the foundation of a brotherhood of nobles who set up a hospital. The brotherhood was confirmed as a nursing order in 1095, and in 1298 it assumed the Augustinian rule, thereby becoming part of the many-branched group of the Order of Augustinian Canons.[2]

This purely Occidental Order of Saint Anthony had no connection with the Coptic Anthonite monasteries, some of which still survive on Mount Kolzim near the Red Sea. It is only through the wonder-working relics that the European order was linked to the hermit-saint of early Christian times who, to the Middle Ages, seemed almost a mythical being and who became for the broad masses an object of special veneration. Saint Anthony's influence on the West, however, is far older than the hospital order that bears his name. The anchoritic colonies of monks he founded in the East served as one of the models for the Western orders. It was "for the brethren beyond the seas"—that is, for the monks in the West—that Athanasius wrote his biography of Saint Anthony which, translated into Latin by Evagrius, was to exert great influence throughout the Western world.[3] Gregory of Nazianzus called it "a code of rules for monastic life written in the guise of a narrative," and Saint Jerome wrote his

Vita B. Pauli to complement and complete the work of Athanasius. Western monasticism came to have a specially high veneration for the saint it thought of as the founder of the *vita contemplativa*, Anthony the Hermit who had been among the very first, on his ascetic path through the desert, to stand up to the temptations and horrors of the Demon and who had pushed on to the ultimate degree of the cenobitic life. No less than Saint Benedict of Nursia appealed to his authority and example. The many-sided influence of his personality was kept alive through the daily reading aloud of the *Collations*, the conversations with the anchorites recalled and set down by John Cassian. Thus, long before the hospital order was founded there had been a cult of veneration of Saint Anthony among the Benedictines and, along with it, depictions of his legend which are not without their significance for the Isenheim Altarpiece.[4]

In their veneration of Saint Anthony, the Occidental hospital order organized in his name concentrated chiefly on those of his character traits as portrayed in Athanasius' *Vita* which had most in common with their own activities: by virtue of his cenobitic life Anthony is also the mighty prophetic miracle worker who pits himself against the power of the Demon, who protects man and beast against temptation and illness, who heals maladies but can also inflict them on men deserving of punishment.[5] He was invoked especially against a gangrenous disorder resembling erysipelas or ergotism which was epidemic in the eleventh century and was called, after him, Saint Anthony's Fire or "holy fire." The hospital order devoted itself in particular to the care of victims of this disease. As early as the twelfth century numerous pilgrimages of the sick began to visit the relics of Saint Anthony. Protector of both men and animals, Saint Anthony became a popular saint among the commonfolk and the mendicant propaganda of the Anthonites, who had the right to solicit funds for their hospitals openly and in all places, contributed even more to implanting the cult of Saint Anthony in the life and customs of the people.

This widespread veneration finally elevated Anthony into an allegorical figure. In astrology, which was linked to medi-

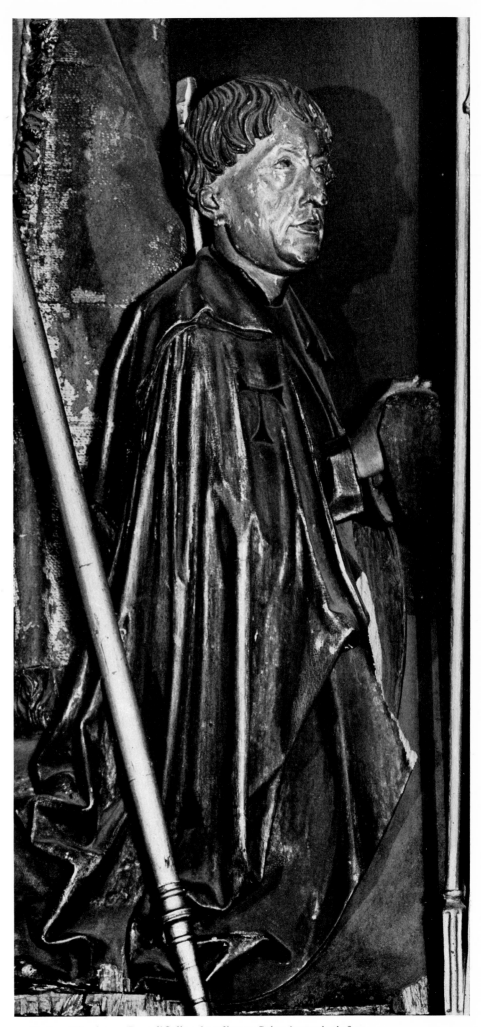

1 Shrine: The donor, Jean d'Orliac, kneeling at Saint Augustine's feet

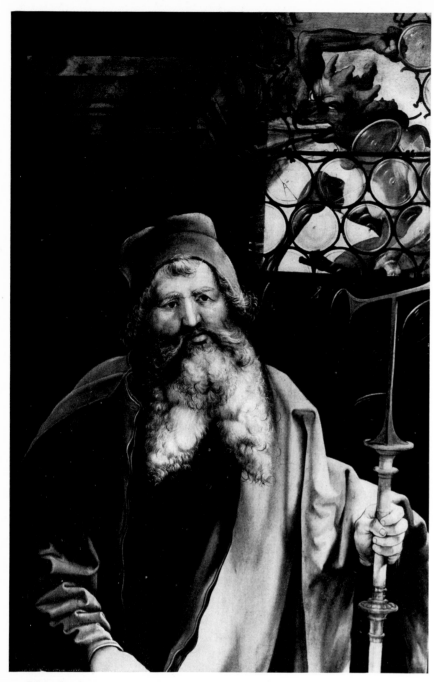

2 Right fixed wing: Saint Anthony the Hermit

3 Right fixed wing: Saint Anthony's pedestal

cine through the doctrine of the four temperaments, he became associated with Saturn, the god who presides over the age of gold according to Hesiod, since Saturn too had to do with the *vita contemplativa*. Thereby, however, Anthony also became the leading example of the "saturnine" man, the *Melancholicus*, the man with a temperament tending to extremes. In many localities his feast day, January 17, marks the start of the carnival corteges to which a great number of folk customs have become attached. Then, too, by his victory over the demons he became the warder of Hell who holds in check the Devil himself.[6]

This is how it happened, then, that in the West the veneration of Saint Anthony came to fall into two main streams, one theological and monastic, the other folkloristic. The folkloristic current had an exceptional impact on the late-medieval imagination, especially in the fifteenth century. The literature of that time embroiders new tales around episodes in the saint's life and interweaves them with other legends. Artists too, Hieronymus Bosch most notably, were inspired by him to fantastic pictorial visions reflecting the all-pervading anxiety attendant upon the end of an age. However, in the monasteries of the Anthonites themselves, especially where a higher theological standard was in force, it was above all as the initiator of the *vita contemplativa* that Anthony was venerated.

This was manifestly the case at Isenheim. One of the more important houses of the Order, its benefices were international, usually assigned by the pope himself. As early as the middle of the fifteenth century the abbey was already doing much to encourage the commissioning of works of art in the region of the Upper Rhine.

About 1460 an altarpiece with side wings was commissioned for the Anthonites' church in Isenheim by Hans Erhart Bock von Stauffenberg and his wife Ennelin von Oberkirch. The triptych, with a *Pietà* in the center and the *Annunciation* and the *Nativity* on the wings, is the work of a painter of the Upper Rhine thought at one time to be the youthful Schongauer himself, though in fact it was a step forward that paved the way for that artist's achievements.[7]

It was about 1470 and under two outstanding preceptors of the monastery, the Savoyard Jean d'Orliac (or, in the Italian he preferred to use Orliaco) and the Sicilian Guido Guersi, that the demand for works of art took a marked upswing. An apparently well-founded tradition ascribes to the two preceptors an extensive activity as builders.[8] Orliaco is supposed to have begun with an accessory area for the choir, described as the *vestibulum chori*, while Guersi is thought to have gone on to vault over the sacristy and choir and probably also to push ahead with the main nave. The result was a consistently planned and unified overall recon-

struction of an earlier church carried through according to the usual plan. During the alteration of the choir the main nave was in use, and on its rood-screen wall about 1475 there was at least one altar dedicated to Saint Catherine and apparently also already one to the Madonna, with wings painted by no less an artist than Schongauer. By 1493 the reconstruction of the choir was so far along that new choir stalls could be installed, and by about 1500 it was possible to institute or renovate the high altar. Finally the work of reconstruction was extended to the main nave and the aisles. At Guersi's death, however, the west facade was not yet completed.

Such thoroughgoing remodeling of the church was possible only because of a generous endowment on the part of the preceptor Orliaco. When he resigned in 1490 his successor and friend Guido Guersi continued his work and made a point of calling attention throughout the church to the original donor. This suggests that Orliaco had already established the entire program for the renovation, including apparently the main altar also. Orliaco came from the Anthonite house in Ferrara and was close to the circle of Aeneas Silvius Piccolomini, the future Pope Pius II.[9] It can be presumed that he was a learned person of some intellectual distinction. For his part, Guido Guersi appears to have taken pains to adapt his predecessor's plans to the changing circumstances. Nevertheless, the Marian altarpiece of Schongauer, whose wings were painted in the 1470s and which was endowed by Orliaco, was not used for the high altar. About 1500 Guersi fitted the wings to a shrine housing a statue of the Madonna (probably the Madonna in the Spetz Collection) and, in so doing, added his own coat of arms together with the image of the original donor, Orliaco. It would seem likely therefore that by that time a new high altar had already been planned and even initiated, so that all efforts were now concentrated on the new undertaking. In the new altar too, however, in the shrine with statues by Niclas Hagnower, once again only Orliaco appears as donor (fig. 1). Since it is not likely that Grünewald was called in until after the painter of the Saint Catherine altarpiece had done his work, he must have found the shrine already on hand when he took over the commission,[10] though there is no reason to assume that any essential change was made in the program already established for the high altar.

Guido Guersi died in 1516, and since the *Gebweiler Chronik* of only two decades later credits him with the high altar also, it must have been completed during his lifetime. With this altarpiece by Grünewald, the two preceptors crowned in incomparably magnificent fashion their work of renovation of the church at Isenheim.

First View

FORM

The Isenheim Altarpiece has come down to us as a fragmentary torso. One must take this fact into consideration for it is more unfortunate than the usual reconstructions that have been proposed would like to make us believe.

When the painted panels and large wooden statues were turned over to Colmar as state property during the French Revolution, they were hastily and carelessly pried loose from the framework of the altar. It was a day and age that saw and appreciated only separate pictures and statues where the Middle Ages had thought in terms of a higher unity, the altarpiece as a whole.

It was in vain that about 1794 two inspectors, gifted with rather more understanding than most, urged that the individual components should be reincorporated into the carved wooden framework of the altar which could still be found at that time in the choir of the church in Isenheim where, damaged as it was, it nevertheless excited the admiration of the two functionaries. Their advice was ignored, and except for some fragments of the frame, the ornamental scrollwork of the shrine, and the crown of a pinnacle from the superstructure, the entire framework fell victim to the fire that destroyed the church itself in the nineteenth century.

The surviving fragments of the frame and the general contours of the wing panels give a good idea of what the original carved wood structure was like. The middle section rose higher than the narrower fields flanking it to either side. Since the framework with elaborately carved ribs and a dense paneling of ornamental foliage in the middle has survived in part, we can presuppose a similar arrangement for the side panels. It is likely that the profile of the upper margin was energetically and firmly delineated and that above it rose the steep architecture of the superstructure. Presumably this structure of the Isenheim Altarpiece was much like that of Hans Sixt von Staufen's altar in the Freiburg minster, airy and loose in composition, a slender projecting ornamental architecture with interwoven baldachins, of which one has survived, and thin Gothic pinnacles. This means that it was quite unlike the openwork spires and luxuriant vine tendrils used in Klem's reconstruction which is often reproduced and has exerted marked influence on our ideas up to now.[11] As a whole the structure of the Isenheim framework was of slender elegance, more light than heavy, with a delicate contrast between the dense ornamental scrollwork and the markedly transparent openwork in the pinnacles of the superstructure. However, since all over the crown and in the framework there were tiny figures, now completely unknown to us, our notion of what the whole structure looked like must remain, at the best, distorted and approximate. Late Gothic altarpieces, and polyptychs in particular, always involved the union of many arts which was characteristic of the universality of the Middle Ages. Architecture, sculpture, and painting all played a part; though, in distinction to the cathedral, in altarpieces it is the figurative arts that have the lion's share. The fact that the altar was endowed by some individual made necessary a public acknowledgment in the visible form of statues or pictures of the patron saints together with scenes from their legends or from the life of Christ. In consequence, an altarpiece constitutes a very special type of commemorative structure which is unique in its capacity to synthesize a diversity of images into a unity. In polyptychs of the later Middle Ages, this complex of associated ideas could be altered at will by making the side wings movable. A special form of this type of altarpiece has as its central core a shrine or tabernacle with carved figures, and in these there is a truly intensive interweaving of ornamental architecture and sculptured scenes. In such altarpieces, however, the painting itself, with its small consecutive scenes stacked in superimposed tiers on the side wings, remained only loosely connected esthetically with the carved central shrine. In these, when the wings are shut the shrine is concealed behind this neutral wall of pictures which, in contrast to the central sculptured portion, constitutes a secondary view—an accessory ensemble—but not the principal image, even in those polyptychs where a double pair of wings makes possible yet another transformation.

Left wing, closed position: Saint Sebastian

whose base is decorated with the egg-and-dart pattern. The column itself rises to a goblet-shaped capital whose carved ornamentation has been metamorphosed into living vine tendrils coiling around the shaft. Sebastian's martyrdom has just taken place. Arrows still vibrate in his calves and chest, though a few have already been removed and have been left propped against the pedestal or tucked into the loop of rope, now torn, that had fettered the saint to the pillar. He has been released from his bonds, has survived inviolate, though blood still spurts from the fatal bluish wounds. A length of red cloth is flung across him like a victor's mantle. Through an open window angels soar above a lovely landscape, bearing a bow and a sheaf of arrows, the signs of the martyr's ordeal, while others hover aloft holding the golden crown of triumphant martyrdom. The saint himself turns toward the viewer in a friendly manner. The harmony between his facial expression, deeply impregnated with a surpassing peace, and the landscape lying serene in the radiance of noon is extremely convincing (colorplate, p. 13). Although what one has here is a picture showing a statue on a pedestal and with all the usual theatrical set pieces familiar from so many earlier depictions of Sebastian, it is based on such a vital conception of time that one finds oneself compelled to speak of it as some kind of paradoxical action.

The central picture seems more unified: Christ on the Cross with mourners on a rocky height, the summit of Mount Calvary from which there is a view across a broad sweeping landscape with a city—Jerusalem—in the valley (colorplate, p. 7). Yet closer examination shows that here too there are conceptions as unorthodox as those in the wings. The personages of the Crucifixion are all detached from the spatial depths and dark shadows of the landscape and brought into the immediate foreground, the plane traditionally reserved for the significant personages and events in devotional pictures. Thus we have the type of Crucifixion with only the few chief personages, a type intended for personal devotions in distinction to the historical-narrative type in which Calvary is overrun by a multitude of figures. The consequence is the utmost degree of "presence,"of liveliness. The gigantic body of the dead Christ is rendered with brutal naturalism and seems to leap out at one with redoubled violence, as if to take the viewer in an ambuscade: flesh in the greenish color of death with the scars of the frightful ordeal, an atrocious benumbed pain written across the face, the mouth extinguished in death, the body pulled up high by the tensile arch of the crossbeam and, at the same time, twisted with the torsion of the tree of the Cross, all limbs ripped out of joint, the loincloth in tatters, while a thorn of the crown pins the head fast in an excruciatingly painful position digging low and deep into the chest (colorplate, p. 17).

The heightened intensity works both ways, and the monumental icon-like impressiveness characteristic of the devotional effigy becomes transmuted here into the violence of a never-before-dreamed-of gesture of suffering caught in all its immediacy, the Passion consummated in pitiless isolation, a lonely dying in an empty world from which even light has fled.

This ambivalence in the meaning of the image is mirrored in the figures to either side of the Cross. At Christ's right the group of mourners falters under the weight of their grief (colorplate, p. 21). Even the Mother of God seems broken, sinking into the terrifying pallor of an ecstatic swoon dire as the death of her Son. In the dissonance of double-grief the disciple John turns to her, envelops the white of her mantle in the luminous red of his drapery. Mary Magdalene, her gown falling in agitated folds, has sunk to her knees in a more vocal, more earthly grief, arms outstretched to the dead Christ and wringing her hands. The steeply declining slope of the stony landscape in the foreground and the diminution in scale from John to Mary to the Magdalene serve to underscore the impression that the entire group is sinking downward, as if the poses of the figures in the *Lamentation* on the predella below were a direct continuation, an echo, of the terrible moment of the Crucifixion above, but gentler now, the tension released, the setting transfigured into a landscape where dawn creeps in slowly (colorplate, p. 7; fig. 7).

Counterpoised to this stream of human grief pouring out as if beyond hope, at the other side of the Cross towers up, legs astraddle, the powerful figure of John the Baptist (fig. 4). The imperturbable gravity of the gesture with which he points to the Christ removes the event from the realm of the momentary, the human, where tears still have meaning, to the sphere of the predestined and inevitable where grief becomes superfluous. This is further emphasized by his symbolic attribute, the sacrificial Lamb from whose breast blood pours into a chalice. But the Baptist's outstretched finger points to the crucified Christ, and in the angle formed by his bent arm can be read a dictum whose meaning seems to be awesomely exemplified in the towering immensity of the body of Christ: "ILLUM OPORTET CRESCERE, ME AUTEM MINUI." (He must increase, but I must decrease.) The allusion itself makes it clear that the exaggeration of the naturalistic aspects of the Passion in the interest of intensified expressiveness was not a simple matter of how the artist felt about his subject but instead, and at the same time, was dictated by a particular theological aspect whose meaning is not revealed at first glance.

When the two panels on which the *Crucifixion* is painted are laid back, one sees the second ensemble: on the left wing the *Annunciation*, on the right wing the *Resurrection of Christ*, in the middle the so-called *Incarnation*, while the predella

continues to show the *Lamentation* associated with the *Crucifixion* of the first ensemble (colorplate, pp. 24–25). The artistic construction of this entire ensemble is of incomparable audacity. On first acquaintance it seems no more than a series of pictures to be read from left to right which is unified by an immense diagonal of figures streaming upward and across the entire altarpiece all the way from the kneeling Virgin of the Annunciation in the lower left corner up to the Christ of the Resurrection soaring aloft on the right. But then one notices that all the sections, but especially the two wings, are based on a fundamental contrast. The Virgin of the Annunciation is wholly bound to an earthly realm where space is something real and tangible, whereas the Resurrection is an awesome explosion out of the world of men and into the remoteness of a gigantic aureole blazing around the sun.

Between two pulled-back curtains the Virgin of the Annunciation kneels on a floor tiled in Italian fashion. Her gown is bluish green, her blonde hair hangs loose, her hands are clasped, and in front of her is an unadorned wooden chest on which lie books (see frontispiece). The topmost book is open to pages on which can be read the text of Isaiah 7:14–15: "Ecce virgo concipiet et pariet filium. Et vocabitur nomen eius Emanuel. Butyrum et mel comedet ut sciat reprobare malum et eligere bonum." (Behold, a virgin shall conceive, and bear a son, and shall call his name Immanuel. Butter and honey shall he eat, that he may know to refuse the evil, and choose the good.) She has apparently just read this text and shrinks back in fright but also with unstinted obedient expectation as the Angel appears, the wind of his flight still whipping his draperies (colorplate, p. 29). He is attired, as if for a solemn ceremony, in yellow lit as from within and with a red cloak, and in his left hand he carries a golden scepter. In the background are other pieces of furniture and more books. Yet, when one looks at the upper half of the picture it becomes clear that the setting is religious, not profane. The foremost Gothic arch might well be the arcade of a middle nave of a church with a clerestory. At the left there is what seems to be part of a crossing arch. Through the arcade one looks into a crossrib-vaulted bay with brightly colored decoration, red crossribs and vegetable motifs and ornamental roundels painted in the segments of the vault. Within that area hovers the dove of the Holy Ghost, and behind it is another bay, a kind of small polygonal apse like a portion of a central-plan building, with green crossribs and with different stonework tracery in each of the windows. Viewed as a whole, the entire architecture seems like a veritable portrait of a Late Gothic interior, painted with utter precision and with the most intense observation of the subtlest reflections of light and color. On the spandrel, however, this straightforward architecture is transformed into something different. Naturalistic tendrils of vines sweep

across it, and in the spandrel of the arch stands the figure of a man wearing a turban who holds up to the viewer an open book which, if one could decipher it, would quite certainly be the same text as that which can be read below, for he is plainly the Prophet Isaiah himself (fig. 8).

The *Resurrection* on the opposite wing is in marked contrast to the *Annunciation* (colorplate, pp. 24–25). In a dark star-studded night, soldiers keep watch at the tomb of Christ. The setting is outdoors, in a hollow surrounded by rocky cliffs. But suddenly the ponderous stone slab of the sarcophagus is shoved to one side, Christ, with graveclothes fluttering in the wind of His rising, sweeps aloft out of the tomb and into a gloriole gigantic as a sun, the watchers in chain mail and jerkins—painted so naturalistically that the garments seem eaten through by rust and moths—tumble together into a clanking heap luridly lit. What surrounds the Christ is no traditional halo but, instead, at least in its sun-yellow center, a light that streams out of the body and visage, transfigured in their very substance and that emanates, in rays, from the wounds in the hands and feet (colorplate, p. 35). In the *Annunciation*, light that has been transmuted into a substance is suggested only discreetly as a delicate halo around the dove of the Holy Ghost and on the Angel's garments. In the *Resurrection*, light becomes the ultimate contrast to the impermanence of everything earthly, to the soldiers delivered over to the decay of rust and the gnawing of moths. It becomes an essential property of the transfigured body of Christ, so that here light, color, and symbolic meaning become one and indivisible.

This broad antithesis between the paintings on the wings compresses the central picture into a composition of unique imaginative force (colorplate, pp. 24–25). Is it, in fact, a single picture? In the middle there is a very emphatic division emphasized by a kind of curtain or banner hanging from a tall jamb. However, it is also perfectly clear that here the artist deliberately created a single, unified space. As on a mechanical revolving stage, where the individual segments are all on the same level but have their own separate stage settings, so here the pictorial space is arranged in a three-quarter round about a kind of post in the center. It is one of the great miracles of art that we should have here a picture of radiant, visionary unity despite the fact that its details simply do not fit together into a harmonious whole. Throughout the picture, not only individual motifs but even quite diverse modes of representation are combined. To the right, a large charmingly gowned Madonna sits holding the Child within a walled garden, the so-called *hortus conclusus*, in front of a broad mountainous landscape (colorplate, p. 45). Of proportionate size, on a scale perfectly right for the infant, are the paraphernalia of the lying-in room round about. But if one looks simultaneously at the Madonna and the landscape one suddenly realizes that the figure is, in fact,

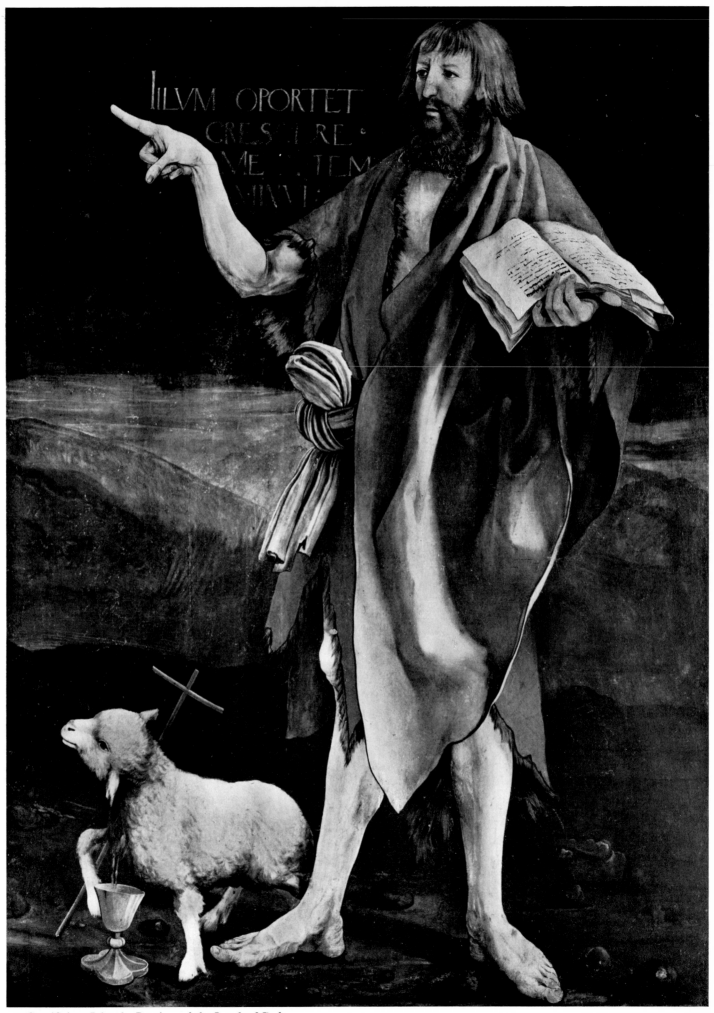

4 Crucifixion: John the Baptist and the Lamb of God

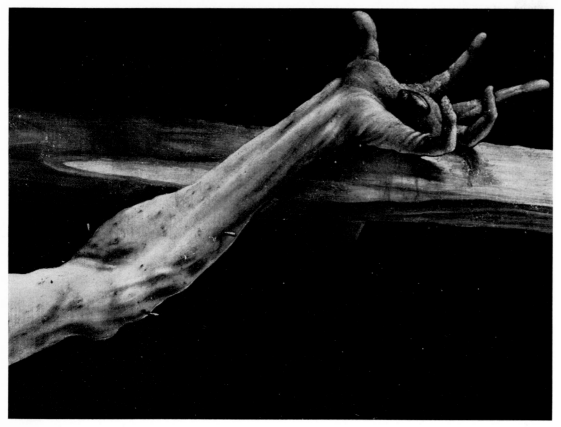

5 Crucifixion: Left arm of Christ

6 Crucifixion: Christ's feet

7 Lamentation (predella): Landscape

Crucifixion: Mary, John, and Mary Magdalene

all by allowing his own subjective imagination to push beyond the commonly accepted barriers between artistic creation and spiritual meditation?

The question of the basic meaning of the Isenheim Altarpiece is, in consequence, a very special problem in art history. Were its content easily comprehensible, even the most broadly thought out, most spiritually moving individualistic treatment on the artist's part could be explained without more ado on purely historical grounds. But how does one explain the fact that both components—artistic form but also content—are so entirely exceptional?

One's first temptation is to try to explain all these peculiarities on the basis of Grünewald's own personality. He must have been wholly extraordinary as both artist and man. His way of depicting things, apart from any question of content, is in itself a unique phenomenon. He cannot be connected unequivocally with either his time or his place. One can scarcely name another artist of the late Middle Ages or the Renaissance with a style so difficult to trace back to any coherent root. Not that Grünewald was without contacts with other artists. To the contrary, it is astonishing how broad a base he had as an artist. He reveals connections—which could only come through acquaintance—with virtually all the art of central Europe at the end of the fifteenth and the beginning of the sixteenth century. He had mastered every aspect of the Late Gothic art of Germany. That he was well acquainted with the art of Schongauer and of the Master E. S. among others we know from his borrowing of many details from their works. The pose of the Saint Anthony on the fixed wing of the first position repeats that of Schongauer's similar figure on his own altarpiece for Isenheim. It was in Schongauer that Grünewald found the characteristic position of the hand clutching a mantle with the little finger extended.[14] Over and beyond such details, inwardly too, in the feeling for tenderness and majesty, he reveals his link with Schongauer. A number of pictorial traits, the fantastic representation of Late Gothic architectural motifs as well as the use of compositions based on large figures, suggest that he must have had contact too with Michael Pacher and Pacher's brother Friedrich.[15] Further, much of Grünewald's expressive severity in overall composition seems to derive from the elder Holbein. The bond with Dürer was one that members of the same generation have in common.[16] It was with and against Dürer that he struggled most. Even the large Madonna of the Isenheim Altarpiece appears to be influenced by Dürer's *Virgin with the Dragonfly* (fig. 27). However, more than anything else they have a common feeling for broadly open landscapes, but where Dürer was already isolating landscape as an artistic problem in and for itself, Grünewald still considered it in terms of its symbolic associations.[17]

Thus, one sees that Grünewald took inspiration from all quarters, and more examples than those cited can be adduced. Yet at no point do we ever find him indulging in that kind of total dependence on an overall approach which is characteristic of a pupil or disciple.

What is more, his sovereign independence was manifested not only toward the artists of his own time. He also made use of artistic means completely unrelated to the age in which he lived. His contemporaries would no longer even consider juxtaposing a piece of architecture and a landscape in entirely arbitrary and symbolical proportions as he did in the Isenheim *Incarnation*. To find something similar one must go back a century, to a work like Broederlam's altarpiece in Dijon (fig. 26). Looking at the *Annunciation* of that altarpiece, with the peculiar relationship in scale and position between the building at the left and the landscape on the right and with the very similar apparition of the angel on the ground before the building, it is difficult to resist the temptation to conclude that Grünewald must have drawn the inspiration for the formal structure of his picture from Broederlam's.[18] At best, though, he could not have borrowed more than the general notion, because the Late Gothic forms of Grünewald's baldachin are so similar to those of a contemporary piece of architecture, the choir screen in Breisach, that one almost has to consider it a deliberate imitation.[19] For all his free exploitation of earlier compositional motifs, however, Grünewald's art was in no way retrospective. The past, older art, seems to have represented for him no more than a handy source of motifs, not something binding.

In any event, the foundations of his style are much broader. His link with Netherlandish painting is closer than that of any other German artist of his time. The notion of depicting God and the heavenly hosts in a gloriole, as in the *Incarnation*, has precedents in similar motifs of Hieronymus Bosch (fig. 24).[20] For the devils in the *Temptation* likewise he borrowed much from Bosch, and in various parts of the landscape in the same picture one seems to detect traits of Bosch's tonal approach to painting. In the final analysis we can only say that basic aspects of the personalities of Grünewald and Bosch reflect the same conjuncture of circumstances, the same epoch. Both play with their highly personal imaginations as an entirely new artistic means for arousing strong emotional responses in the viewer. And, for all that, Grünewald was not really dependent on Bosch, nor is the world he shows us shattered beyond hope like that of the Netherlander.

No less significant was his contact with Italian art. Certain correspondences in form with Mantegna's art have already been pointed out by other scholars.[21] However, Grünewald's contact with Italy goes well beyond that. The *Resurrection* marks the first appearance in Germany of the Italian form in which the risen Christ soars above the tomb.[22] Furthermore, the pose of the hands and legs of the soldier sprawling

in the foreground is suggested directly by the very same figure in Luca della Robbia's relief on the same subject in the Duomo of Florence (figs. 33, 34). Likewise the raised hands of the resurrected Christ and the appearance of the wounds must go back to recollections of Luca's relief of the *Ascension* (fig. 36).[23] These, in any case, are no more than borrowings of forms. Grünewald as a total personality was much more decisively touched by the Italian art of a later time, that of the beginning of the High Renaissance. In its concentration of illumination on figures in front of a dark background the *Crucifixion* could not have come into being without the contrasts of light within space found in such paintings of Leonardo da Vinci as the *Madonna of the Rocks* and the *Last Supper*. Similarly the monumental style of gesture, the use of caricatural exaggeration as a means of characterization, the conception of landscape as a vehicle for contrast in light, these all link him to Leonardo entirely aside from any direct imitations of motifs. In addition, the highly painterly differentiation of the garment of the large Madonna in the *Incarnation* must derive from acquaintance with the early works of Titian.[24]

All these various relationships strongly suggest that Grünewald was widely traveled. It is scarcely conceivable that a German artist of that time could have attained such personal independence entirely on his own and without leaving home. But Grünewald was one to reject outright as a whim any notions from outside or else to rework them to his own ends with sovereign skill. One is tempted to think of him as a self-taught artist, as though it might be possible to attain such a high art in painting and such mastery of all technical means without undergoing intensive schooling. His mastery of painting technique goes far beyond what was usual in his time: the trees on the mountainside in the picture of the meeting of the two hermit-saints are rendered as pure "color-form," something that was to become common only with Impressionism (colorplate, p. 53).

The unique achievement of Grünewald does not at all consist in taking up and reworking highly diverse ideas from others but, much more, in intensifying all the means of art into a magnificently expressive style which can no longer be termed medieval but, at the same time, does far more than merely take over the principles of the Italian Renaissance. Grünewald is still linked to the Late Gothic by his highly imaginative interlocking of categories of representation such as the pictorial with the sculptural or the ornamental with the living, evidence that his spatial conception was still under the sway of an autonomous decorative principle. But he also knew—as the figure of Sebastian demonstrates—what constitutes a human being, not only on the basis of naturalistic and psychological observation of details but, even more, by his ability to grasp the spiritual-corporeal totality, to see a man as a monumental symbol of the human embodied in a form, as real and superreal substantiality, and this was a conception promulgated by the High Renaissance. Indeed, he elevated this substantiality still higher by making a clear distinction between what is earthly and what is transcendental. The Middle Ages were still unconscious of any opposition between the supernatural and the natural, but such a differentiation lies at the very base of Grünewald's thought. He portrays the creatures of Heaven as an aggregate of some other substance, as deriving their reality from light. The Renaissance eschewed this type of contrast and gave what is sacred a place within the sphere of real things. But Grünewald dared to stand alone, to be the only one to conceive the new feeling of existence as an antagonistic countertension to the transcendental. It is for this reason that in his work what is medieval in content appears displaced onto the plane of the visionary. And for that reason also it is scarcely meaningful to say that the art of Grünewald is "anticlassical" and in opposition to the "classicism" of the Renaissance.[25] It was not conceived as a countermovement to Italian art but, instead, as a unique and solitary art going in its own parallel path.

In a highly personal and peculiar manner, Grünewald carried over medieval subject matter into his art as something which, in a new sense, was both creative and highly influential in its impact on his forms. That is why it is indispensable to return over and over again to the attempt to track down what really lies behind the very peculiar iconographical program he embodied in paint. Only in that way can the secret of this altarpiece be fully disclosed.

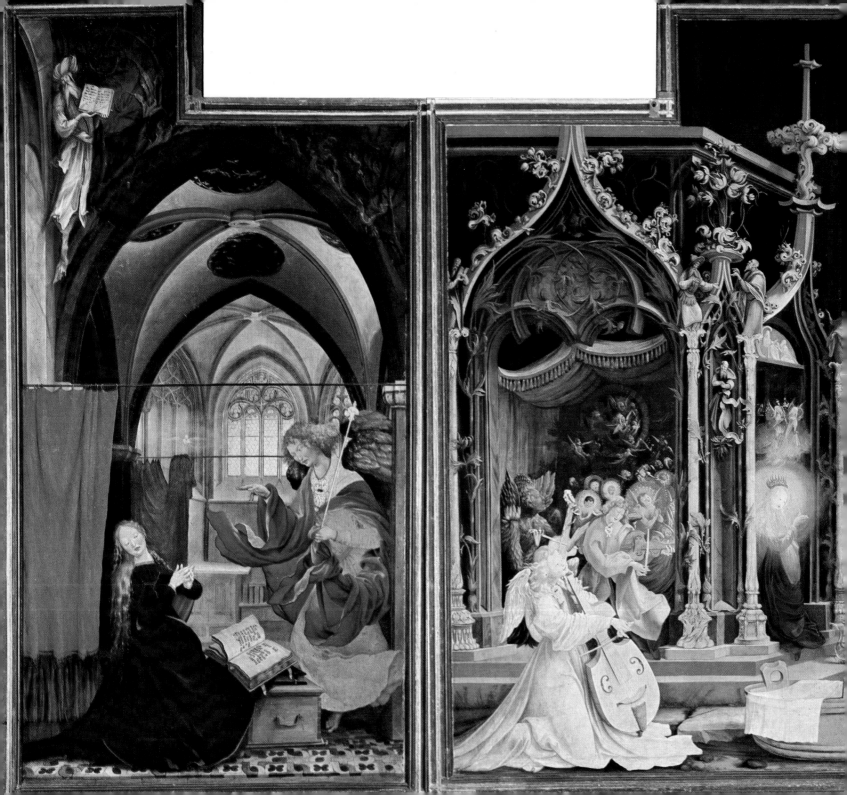

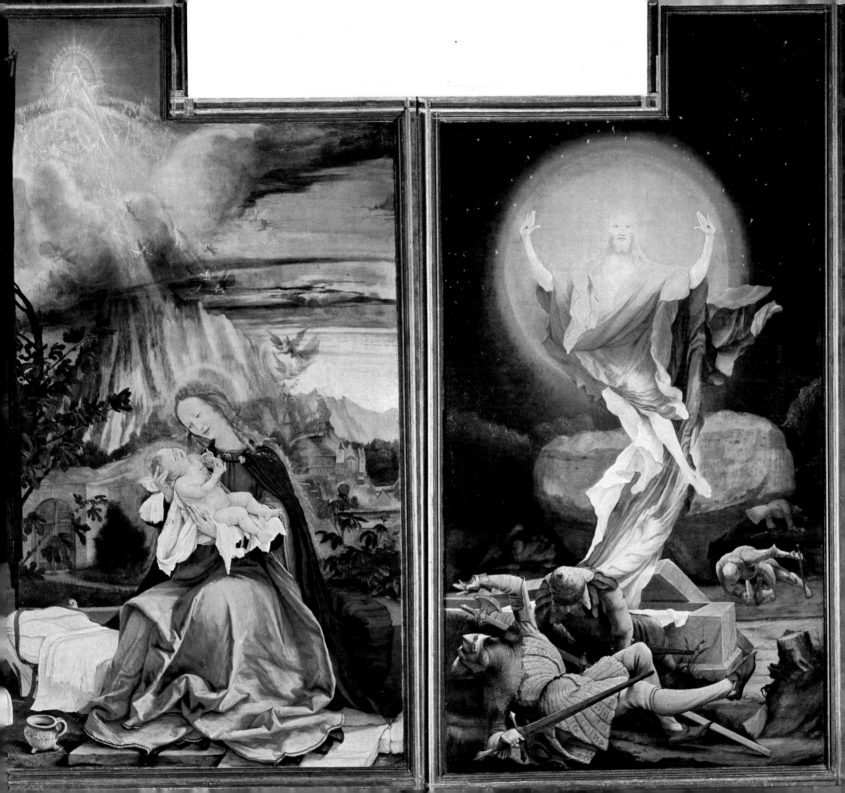

The middle position: The Incarnation

Second View

Saint Anthony as Founder of the *Vita Contemplativa*

Efforts to explore the inner meanings of the Isenheim Altarpiece have concentrated for the most part on the central panel of the second position, the other pictures being, presumably, easier to comprehend. As for the statues in the shrine, the general attitude is that they are not really involved in the overall meaning of the altarpiece. In contrast to Grünewald's pictures, passionately expressive and impregnated with cryptic meaning, the shrine and its simple row of statues of three saints are dismissed as a mere juxtaposition of the sort of figures that had for a long time been customary on the carved wooden altars of southern Germany. The painter had no choice, it is proposed, but to adjust himself as well as he could to this already existing shrine.[26]

Even if one is convinced by that argument, any exploration of the meaning behind the altarpiece must begin with the shrine. For better or worse, it is the central core of the entire work. If nothing else, it must have had a decisive influence on the two lateral wings that Grünewald added to it.

As we have seen, the statues in the shrine were not arranged in a simple row, one after the other, but were organized in a tripartite graduation in scale which clearly corresponded to the different levels of significance of the figures (fig. 19). The largest is the imposing effigy of Saint Anthony enthroned in his abbot's chair, strictly frontal in pose and impressive in bearing. There follow, considerably smaller, the two attendant saints, Jerome on the right and Augustine on the left, and finally there were two small figures at Anthony's feet, bearing votive offerings. (These figures are now in the Böhler Collection in Munich and therefore do not appear in our photographs.) The central position of Anthony is further emphasized by the gestures of the others. All the figures looked toward the saint enthroned in the middle, the great Doctors pointing to him with unforgettably elegant gestures, the small figures with their offerings

gazed up at him or out at the viewer in touching veneration. Now it so happens that this entire arrangement is unusual in a German sculptured altar. It recalls so emphatically the Italian *sacra conversazione* that here one must assume some direct intervention on the part of the Italian who commissioned the altarpiece. It seems probable that right from the start, even in the shrine, he was hinting at something special in the overall iconographic program.

In this composition, whose form is determined by its content, the two small figures at the saint's feet constituted the link with the folkloristic iconography of Saint Anthony. The burgher on the left offered him a cock, the peasant on the right a pig. Pilgrims' devotional prints bearing a representation of Saint Anthony usually include similar figures offering some animal or other. A large woodcut in the print collection in Munich dating from the middle of the fifteenth century shows a whole series of such figures.[27] Since there they offer him other objects as well, including crosses and small human figures apparently made of wax, one can assume that these are meant to be regarded as symbolic votive offerings. In the villages, pigs were fattened up as gifts to Saint Anthony's abbeys. Other animals, domestic ones in particular, were consecrated to him, and he protected them from diseases. The motif functions here, on our altarpiece, as a reminder of the peace the saint concluded with the beasts as against the war waged against him by the infernal bugbears.[28]

Anthony is portrayed enthroned and in a pose of impressive dignity (fig. 20). In the course of the Middle Ages the motif of the throne, originally reserved to the *majestas domini* and the Virgin Mary, became increasingly attributed to saints who as titulars of pastoral or teaching offices had right to an armchair. Here the Saint Anthony is, in fact, characterized as abbot by virtue of his throne, the staff signifying his pastoral office and the book his role as educator. The legendary founder of the Anthonite Order presides like a professor *in cathedra* above the main altar to either side of which were the choir stalls of his "pupils." The armchair may have had the accessory meaning of a judgment seat, and the fact is the

Middle Ages attributed to Anthony a role as judge and avenger also. He not only healed illnesses, especially the malady known as Saint Anthony's Fire, but he could also visit them on men as a punishment. Sick people known to have dire offenses on their conscience were not admitted to hospitals until they had done penance. In those cases where it was suspected that the disease named after the saint had been inflicted by him as a punishment it was called Saint Anthony's Revenge. The whole idea goes back to an episode in the *Vita B. Antonii* in which Athanasius recounts how judges came to Anthony with the contending parties to solicit his counsel. And like his prototype Elijah he warned an unbelieving general, Ballachius, of the divine wrath threatening him for his persecution of monks, and God's will was done. This is why we find him on pilgrims' devotional prints depicted as enthroned over a fire—Saint Anthony's Fire—with which he punishes transgressors.[29]

Half-hidden under the saint's mantle on our altarpiece is the well-known emblematic animal of the Anthonites, a pig. The pig played a prominent part especially in the Anthonites' mendicant propaganda among the commonfolk. In earlier times Anthony's animal was taken to be a personification of the vanquished Demon. However, in the *Vita* it is said, "Nor over the pig does the Devil have power,"[30] so the most humble of beasts is really a symbol of the powerlessness of Hell. But on a deeper level of meaning, in the astrological literature already referred to, the pig is also the emblematic animal of the melancholic, of the Saturnian man of whom the cenobite Anthony was considered a particular embodiment. The anchorites were numbered among the so-called planetary Children of Saturn, and Anthony himself was even at times portrayed outright as Saturn.[31]

The enthroned Anthony of the Isenheim Altarpiece and the small figures with their attributes are therefore in a clear iconographical relationship to the general cult of Saint Anthony. However, none of this explains the presence of two Doctors of the Church, Jerome and Augustine, nor of the symbols of the Evangelists in the scrollwork foliage above the central figure. The symbols of the Four Evangelists were part and parcel of the medieval depiction of the *majestas domini*, and their appearance above a mere saint, even if enthroned, comes perilously close to sacrilege. In this case, though, they cannot be taken to pertain to Anthony himself but, instead, to the two Doctors of the Church and the Christ with the Twelve Apostles in the predella. The late Middle Ages did, in fact, occasionally juxtapose the four Doctors of the Church with the symbols of the Four Evangelists to exemplify the Christian doctrine of salvation. Thus the bull became associated with Augustine, the angel with Ambrose, the lion with Jerome, and the eagle with Gregory. The best-known example is an engraving by Master E. S., the so-called *Paten* where they are grouped in that arrange-

ment around a depiction of John the Baptist in the desert.[32] It is manifestly with the same meaning, then, as supporters of one who teaches the doctrine of salvation through Christ, that they appear in association with the arch-anchorite Anthony. This is the only possible explanation of the presence of two Doctors of the Church as auxiliary saints to Anthony, especially since the choice of Saint Athanasius, Doctor of the Church but also Anthony's biographer, would seem more appropriate. There is also the fact that these two Doctors have a special relationship to the Anthonite order and to its patron saint. In 1298 the order took over the Rule of the Augustinian Regular Canons of which, during the Middle Ages, the authorship was attributed to Augustine himself. Moreover, in his *Confessions* Saint Augustine refers specifically to the important part played in his conversion by the *Vita B. Antonii*.[33] Similarly, the example of Saint Anthony plays a particular role in the writings of Saint Jerome who also, in his *Vita B. Pauli*, contributed a few characteristic touches to the traditional portrait of Saint Anthony. So there is nothing arbitrary in the gestures with which the two Doctors of the Church point to the saint, symbolizing as they do the debt of the great teachers to the special theological significance of the teachings and life of Saint Anthony.

The association of these Doctors of the Church with Anthony cannot, in any case, be explained by reference to the widespread veneration of Anthony throughout the West as the great protector against disease. It is much more a clear allusion to the hermit-saint as the originator of the monastic way of life, of the *vita contemplativa*.

THE TWO WINGS

The Temptation of Saint Anthony

On the right wing we have what is called the *Temptation of Saint Anthony* but is, more correctly, the ordeal of the saint under the attack of a horde of demoniac hybrid creatures who are rendered with extraordinary imaginative power (fig. 16; colorplate, p. 61). The subject and content of this magnificent painting have often been traced back to Schongauer's engraving on the same theme which seems to have been done as a pilgrims' devotional print for the Isenheim Anthonites (fig. 29).[34] It can be demonstrated that this engraving was the prototype for a number of similar representations, and Grünewald was quite definitely influenced by it in certain details, notably in his conception of the demons. The two scenes are otherwise in no way identical. Schongauer shows the saint soaring aloft while beastlike demons do their best to drag him down, whereas Grünewald depicts him thrown back helpless on the ground. It has been

suggested that Grünewald was representing a later moment of the same scene.[35] But Schongauer's is in fact an entirely different episode, one that occurred much later in Anthony's life and has a quite different significance, namely, the transportation of the saint into the skies. Anthony saw himself in a vision ascending to Heaven while the demons, in the guise of sins, attempted to hinder him.[36] Grünewald's picture, on the other hand, is based on the story of the saint's temptation by tormenting demons in the tomb where he made his home. The story is perfectly clear in the *Vita B. Antonii* and the body of legends later accrued to it. At the start of his career as a hermit, Anthony took up residence in a ruined tomb. There he was often attacked by demons who inflicted great pain on him. On one occasion, although prostrate and vulnerable, he renewed his defiance of the demons, asserting, "Here am I, Anthony, and all your torments will not drive me away from the love of Christ." Whereupon the evil creatures fell on him in yet greater numbers and with redoubled fury. The entire place swarmed with apparitions of all sorts of wild beasts which pressed him hard. He, however, "although feeling an ever more frightful pain throughout his body, nevertheless lay there unafraid and still vigilant in spirit." In that dire moment he suddenly saw Heaven open itself and a ray of light stream down which caused the demons to vanish. He recognized the presence of Christ, and almost reproachfully addressed Him, saying, "Where were You, why did You not appear at once to spare me these torments?" To which the voice of Christ replied, "Anthony, I was here, but I bided my time and observed your struggle. Because you held your ground and did not give in, so shall I make of you a helper-in-need at all times, and it shall be that your name will be celebrated in all places." Thereupon Anthony raised himself up and "so much had he been given new strength that he felt himself to possess more power than that which he had had before."[37]

This temptation is therefore in no sense what the word suggests today, an attempt at moral corruption. Rather it is a vision of the demoniac, the frightful sight of Hell's power as it was visited upon the hermit in his solitary way in the desert. The anchorite, especially the Anthony we find in Athanasius' *Vita*, models himself after the Old Testament prophets.[38] His aim is to become a latter-day prophet and "to learn always from the way of life of the great Elijah, as in a mirror, how his own life should be constituted." Like Elijah therefore he goes into the desert. But the country into which he makes his way is—according to Isaiah 24 and 34—accursed, for it has given itself over to heathendom. It has been laid waste (Isa. 24:1) and its cities broken down (Isa. 24:10). It has been delivered over to demons and devils (Isa. 34:13–14). Every anchorite who goes into the desert challenges their hold over that patch of earth. It was not without forethought that Anthony first bedded down in an

old and—naturally—ruined tomb in the vicinity of his native place and later, in the desert, in an abandoned fortress. These were the places where the demons of the pagan world lingered on, and he set out to defy them on their home territory. It even happened once that the demons came right out and put the question to him: "These lands are ours. What business have you rummaging about in the desert? You will never manage to escape our snares." But, like an ancient hero and Old Testament prophet, his valor did get the better of them and proved how impotent evil really is. This notion of the powerlessness of the demons plays a considerable role in the *Vita B. Antonii*. Anthony himself, in a great discourse, explains all about their methods of attack.[39] They first try to deflect the anchorite from his chosen path by instilling in him evil thoughts and then by exciting his senses. As a last resort they launch a decisive attack in which they present before his eyes an illusion of their great and invincible power. Fear of this power over men is meant to convince the anchorite of the impossibility of the way he has set for himself. They pretend that they can destroy everything. They make it seem as if his poor shelter has burst apart and gone up in dazzling flames, for they "blind men with the reflection of the hellish fire in which they themselves burn." They hoax their victim into believing that they have power over Good as well, disguising themselves as psalm-singing monks or indulging in a devilish aping of the liturgy. To no avail, for Anthony gives reassurance over and over, and most impressively, that through Christ the demons have lost their power. They can do no more than frighten men with shams. Their aim—and here one senses that the fourth century, when Athanasius wrote, was one of those periods when the world grows old and an age approaches its end—is to sow cosmic anxiety and despondency. But the anchorite must learn to distinguish the various spirits. Anthony states specifically that one can tell if one has to do with a good or an evil spirit by the feelings it engenders, "cheerful resolution, confidence, and renewed strength" or else "terror in one's soul, confusion and disorder in one's thoughts, intoxication and disarray in one's senses, and utter discouragement."

The all-out terrorist attack on Anthony took place at the very start of his career in the desert. It was then that "the Master" stood aside to watch how His saint comported himself and thereafter endowed him with new strength. Only after having passed this test did Anthony truly have the power to pursue his way into the waste places. The episode quite certainly has a didactic purpose, to recommend *humilitas*, the basic virtue of the hermit and the one which makes him persevere with modesty and pluck against all the vexations of the Evil One. Humility will protect the anchorite not only against moral temptations but also during the physical and spiritual suffering he must endure on his progress toward the Good. The virtue of *humilitas* is the indis-

shall be opened. . . . Then shall the lame man leap as an hart, and the tongue of the dumb sing: for in the wilderness shall waters break out, and streams in the desert. And the parched ground shall become a pool, and the thirsty land springs of water" (Isa. 35:5–7). The high mountain is "the mountain of the Lord's house . . . in the top of the mountains" and in the realm of peace (Isa. 2:2–5; Mic. 4:1–3).

The last and holiest place in the "blossoming desert" is the "cave" of the hermit. This is the sheltered confine within the gaze of God, where "the just blossom like a palm" and "with joy . . . draw water out of the wells of salvation" (Isa. 12:3; see also 35:7). Here the anchorite becomes fully the new prophet. Like the "first" hermit Elijah, ravens bring him the bread of divine nourishment. Heaven opens above him and will soon take him up too, the hermit Paul, as it took up Elijah. Anthony himself explained the symbolic meaning of the cave after his return from the meeting: "I have seen Elijah and John in the desert, I have in truth seen Paul in Paradise."

This explains the significance the encounter had for Anthony and why it is depicted here. Through it he was shown the last and highest step in the life of the anchorite. He was taken up into it, into the "cave" where Paul dwelt surrounded by all the symbols of union with the Divine. He partook with Paul of the divine nourishment. However, the holy dispute between them symbolizes the fact that Anthony had now traversed this highest step and was thenceforth Paul's equal.[47]

While Grünewald's landscape here is a typical fifteenth-century composition constructed in projecting stage flats, he nevertheless took pains to bring out the special significance attributed to it in his literary source. This becomes clear as soon as one looks at the treatment of the same theme in earlier or contemporary art. In his drawings and woodcuts on this subject, Dürer usually did not portray the cave but, instead, only an open landscape as an allusion to Eden (fig. 30).[48] The only liberty Grünewald took with the account in the *Vita* was to embellish it by adding the stag and the hind. In this special form that motif appears to come from the *Vita* of Saint Giles,[49] one of the first anchorites in the West, the "Paul of the Occident," who lived in a place surrounded by thornbushes (as in fairy tales) and open to the sky. Visitors found him with a hind at his feet which nourished him with its milk, and the hind in Grünewald's picture is obviously a reminiscence of that motif.

The significance of the choice and juxtaposition of these two scenes—the Meeting and the Temptation—reveals itself fully only in relation to the symbolic allusion to Paradise contained in the encounter between the two hermits. The Temptation is the first step, the precondition for the cenobitic life, the passage through the "evil places" where lurk demons whose attacks the hermit must learn to with-

stand. The Meeting is the goal, the highest step in the anchorite's progress, the Paradise within the eye of God reserved to the new prophets.

The plants portrayed with naturalistic precision in the foreground are likewise immediately related to the conception of the cave as the Paradise Garden. A number of them—notably ribwort, plantain, vervain, crowfoot, spelt, white dead-nettle, germander, white clover, poppy, and cross-gentian—can be identified as medicinal herbs used against Saint Anthony's Fire or other severe illnesses as specifically indicated in the herbal books of the time, especially the *Hortus sanitatis* published in Mainz in 1457. Since these are plants which, in nature, do not grow in the same places or at the same season, their juxtaposition must imply something like a medical prescription.

In the cave, the anchorites' Eden, grow those herbs used against the illnesses of which some of the demons in the *Temptation* are pictured as carriers. The symbol is twofold: diseases as something concocted by the demoniac forces but also as a punishment, a concept found already in the New Testament. By implication, then, the lonely way of the hermit would represent one means of curing such ills.[50]

Thus we see that both of these pictures are symbolic landscapes whose meaning is stated unequivocally in the original sources. The selection of these two particular episodes out of so many others in the lives of the two saints can only have been determined by the specific conception which lies at the root of the entire program for this altarpiece.

THE MIDDLE POSITION

The Annunciation

It is the ensemble of the middle position that presents the thorniest problems to one analyzing the content of this altarpiece. Here virtually every detail is exceptional in artistic terms and unique in meaning. Any attempt to explain the altarpiece must come to grips with these three pictures in particular.

Our examination of the general structure of the altarpiece has equipped us with certain bases for determining the inner meaning of this ensemble. We know that the three pictures present something more than simple narrative episodes. While each seems to possess a pictorial conception complete in itself, space and setting are treated unequivocally in the two wings only. In the central picture divergent and mutually contradictory types of representation are brought together on a common plane with the result that, without ulterior explanation, one simply cannot make out any scenic connection between them. Nevertheless the pictures on the wings are not wholly unrelated to that in the center.

Important motifs such as the nimbus of light are used on the wings (in the *Resurrection*) as well as in the main painting. It stands to reason then that the entire ensemble of the middle position must be based on a single, all-pervading theological idea not necessarily apparent when the pictures are taken singly but resulting from their combination. The wings and the central painting are quite definitely inseparable. However, since the wings illustrate immediately identifiable Biblical scenes, they offer the best point of departure for any examination of the overall theological content.

The first episode in the sequence is the *Annunciation* on the left wing (colorplate, pp. 24–25). In it the figures and the treatment of space are more earthly, more related to what we know and recognize, and this, along with the unequivocal character of the iconography, seems at first glance at odds with the other pictures in this ensemble. It has always been regarded as the most unproblematical picture in the altarpiece, but that in itself demands some explanation within the context of this highly complex polyptych.

With its delicate reflections of real light, the setting, a church interior, seems definitely to belong to the here and now, and the attempt has been made repeatedly to identify it as some particular place the artist himself may have seen. Likewise it is thought that the Mary, with her peasant-like features, might be a portrait (see frontispiece).

It so happens that the Annunciation, as an episode in itself, was given a kind of liturgical dramatization in churches during the Middle Ages. This occurred chiefly in the so-called Golden Mass, a votive mass in honor of the divine motherhood of Mary and one to which was attributed special efficacy in securing grace. For the Epistle the mass used Isaiah 7:10–15, the very text that can be read in Mary's open book in Grünewald's picture, and the Gospel reading was the story of the Annunciation as told in Luke 1:26–28. The individuals acting the roles of Mary and the Angel were concealed behind curtains in the side nave which were drawn back, at the reading of the Gospel, to let the congregation watch a brief dramatic dialogue during which a dove was released from the vault.[51] In Grünewald's painting there are two such curtains drawn back in the side aisle, though Mary kneels so far in the immediate foreground that it does not consciously occur to the viewer that she must previously have been hidden behind one of the curtains.

Despite such similarities, it is scarcely imaginable that it was Grünewald's intent to portray an actual Golden Mass. The church interior and the curtain are common in the iconography of the Annunciation which, in increasing measure throughout the fifteenth century, was pictured in a churchlike interior, almost always a kind of side aisle, often with convexities like projecting bays. Nevertheless an altar is never shown, so such settings cannot be identified incontrovertibly as church interiors. The fact is, the aim is not to identify the house of Mary with a church but, rather, to give a pictorial equivalent for the metaphor Maria-Ecclesia. This would seem to be Grünewald's intention here, and an interpretation of this sort is clearly alluded to by the sacred text lying open before Mary. All commentators have been struck by the fact that this is not the simple passage found in the Bible but instead the repetitive formula of the versicle in the Breviary. In an erudite analysis, Joseph Bernhart was led to conclude from this that the entire composition of the altarpiece must therefore have an internal connection with the Breviary, and indeed he tried to base his entire interpretation on that supposition.[52]

However, here the allusion to the Breviary has a quite different and clearly ascertainable significance. One version of the Annunciation story has it that Mary conceived in the mystical contemplation of the salvation of mankind while she was reading this same passage in Isaiah.[53] This would make Mary the foremost exponent of the monastic *vita contemplativa*. Accordingly, she is shown reciting her prayers from the Breviary, the book of offices used by those in holy orders, and her conception of Christ is presented as, at one and the same time, an act of contemplation of Divinity.

The Resurrection

In contrast to the closed world of the church interior in which the *Annunciation* is set, the *Resurrection* is a veritable triumph of liberation (colorplate, pp. 24–25). With magnificent élan the risen Christ bursts out of the narrow confines of the heavy stone sarcophagus to soar into the boundlessness of the heavens: from terrestrial gloom into the glory of light. The event is portrayed with all the tension produced by an unprecedented juxtaposition of opposites as a vision of the sun blazing in a star-studded night sky.

None of the watchers at the tomb sees the miracle. Catapulted onto the ground, they avert their gaze or jam their helmets down over their faces: the light of Glory is more than human eyes can endure.

The figure of Christ shoots upward in a superb union of repose and movement, immersed in a gigantic nimbus of circles of varicolored light (colorplate, p. 35). The inner sun-yellow core of the gloriole dematerializes the face and upper body and dyes yellow the drapery over His shoulders. The core is surrounded by a further circle of reddish light which transmits its radiance to the other parts of the winding sheet and, in turn, goes over into an outer ring of blue light whose reflection gleams on the draperies trailing far below. Hands upraised, Christ exhibits the wounds as the sign that the sacrificial death that will bring Redemption has been consummated, and from them stream rays of yellow light. The body itself is transfigured. It is no longer the flesh that

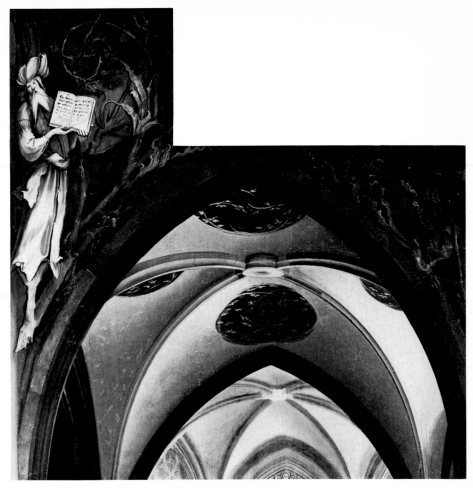

8 Annunciation: Arch with the Prophet Isaiah

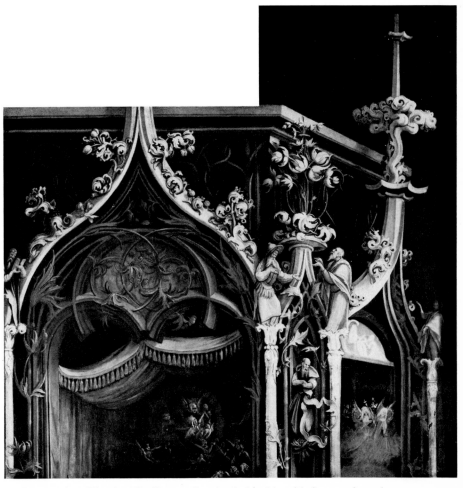

9 Incarnation: The Angelic Concert showing baldachin with figures of prophets

10 Incarnation: The Angelic Concert showing winged figure with streaming
 diadem within a blue gloriole (the Angel Gabriel)

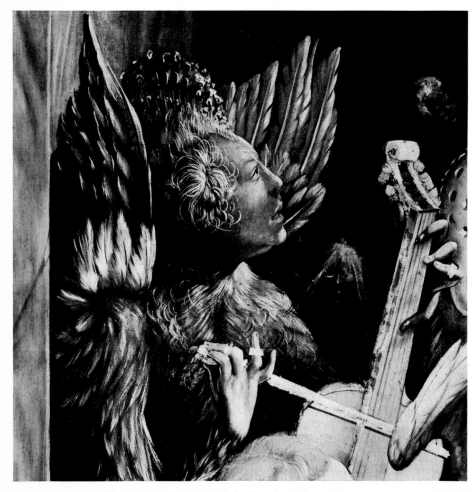

11 Incarnation: The Angelic Concert with feathered angel musician

Incarnation: The Angels Beneath the Baldachin ▷

crown as a modification of the "crown of twelve stars" she should wear in accordance with the text. As for the completely unexpected addition of the apocalyptic nimbus of sun to the figure of the *exspectatio partus*, he explains it away as a mere metaphor, citing in his support a well-known passage in a homily of Saint Bernard which equates the apocalyptic woman of the sun with Mary taken up into Heaven: "You clad Him in your flesh and He clad you with the radiance of His majesty." However, what Bernard of Clairvaux intends by this is not a comparison with the terrestrial person of Mary, a comparison that in any event could be applied *ad libitum*, as it were, but, to the contrary, two quite different things. The clothing with flesh is the earthly Incarnation, whereas the clothing with the radiance of divine majesty concerns the Transfiguration of Mary after her Assumption and her Coronation as Queen of Heaven. Thus in the Apocalypse, the bride of the sun is the transcendental Mary taken up into Heaven. Now, for all that Bernhart's reference to the apocalyptic bride of the sun is undoubtedly an essential contribution to the interpretation of the Madonna beneath the baldachin, it is nevertheless irreconcilable with the notion of an earthly *exspectatio partus*.[68] If Grünewald employs the gloriole of sun in the *Resurrection* on the right wing as a completely unequivocal theological symbol of the passage of the transfigured flesh into the divine and intelligible existence of light, it is unthinkable that the same nimbus of light should be utilized in the contiguous picture as a mere poetic metaphor for a personage who, at that particular point in her history, still belongs to the earth.

Nevertheless, Bernhart considers the right half of the picture to be likewise an elaboration in symbolic terms of the basic scene of the Incarnation. Thus the Incarnation is consummated in the large Madonna with the Child in her arms and seated on a stone bench. The symbols that illustrate this are distributed around the Madonna to form a splendid example of landscape art. The mountain in the background symbolizes the Madonna herself, the mountain from which the cornerstone, Christ, was broken off.[69] The closed garden and the red rose are symbols of her virginity. Less convincing is the characterization of the cradle—an obvious item of furniture for any newborn child—as the bridal bed of Christ, let alone the body of water to the right of the Madonna which is said to be the *fons amoris* or the abbey rising above it defined as the *civitas dei* or the *templum Salomonis*. Other motifs found here and there in the picture do not pertain to the Madonna in Bernhart's interpretation, for instance the bathtub, said to be a symbol of the purifying bath of Baptism, or the chamber pot alongside it (fig. 14), which is said to symbolize the filth of sin.[70]

The fig tree is taken by Bernhart as a sign of the messianic Kingdom of Peace (fig. 13), a realm further denoted by the landscape as a whole, the spiritual Eden of the New Adam.

Here again a complex group of symbols is converted into an overall theological conception signifying the transformation of the world through Redemption, a conception which makes it possible to link up the iconographical formula of the Madonna in the landscape of the New Eden with the tidings brought to the shepherds and the decreeing of Redemption by God the Father in the heavens above.[71] But this means that the two parts of the picture can no longer be defined as members of a single pictorial action.

The attempts of other writers to decipher the meaning of this picture likewise find themselves compelled to deal with the juxtaposition of the two figures of Mary not in terms of two scenes in sequence but rather by reference to some general theological program centering around contrasting ideas, and some of those writers have also taken pains to preserve in their interpretations some reference to the Nativity, to Christmas, as an essential factor in the picture.

Thus H. Kögler holds that the two halves of the picture are an illustration of the double aspect of the Nativity song of the angels.[72] To the right, then, we would have the Christmas episode as seen from earth (*pax in terris*), to the left the Adoration of the Madonna as Queen of Heaven (*gloria in excelsis*), since because of the Incarnation of Christ the ranks of the angelic choirs will become replenished again by saints.

Here we have a very important point of departure for an interpretation. It was given a more straightforward definition by F. Schneider and R. Günther,[73] both of whom saw it as the effect of the divine decree of Redemption on the worlds of both earth and Heaven. Thus the two halves of the picture would juxtapose temporal humiliation (the birth of Christ) and celestial glory, with redeemed Christendom personified on the left as the *anima fidelis* of the mystics (Schneider) or as the *sponsa Christi* (Günther) and, on the right, as the Mother of Christ.

This approach is carried even further by H. Feurstein[74] and W. K. Zülch[75] on the basis of passages in the writings of Saint Bridget of Sweden, and they also combine it with elements from previous interpretations, so that in the last resort the two Madonnas can only be defined by completely vague formulations in modern terms. Thus, the Mary on the right is to be thought of, we are told, as "embodiment [*Gestalt*], as Woman, as earthly executrix of divine providence" (Feurstein) while the Mary on the left is "Idea, eternal thought, awaking, germinating, growing, Mary before time, on the threshold of time, who gazes on herself as the fulfillment of time" (Feurstein, Niemeyer) or else "*Maria aeterna*, foreseen in the decree of God, before the creation of the world, as the bearer of God in the state of expectation and as leader of those who wait" (Zülch).

Still, even those who attempt to interpret this picture by applying the methods of strict iconographical research find that they have no choice but to follow the same path as those

basing their interpretations on theology alone, a path that leads from the scenic representation of the Virgin in the Temple with her premonitory vision of the birth of Christ, then by way of the *exspectatio partus*, to conclude finally—by ever broader penetration into Grünewald's picture—in a completely generalized and complex representation of the essence of the Madonna, one in which not only the historical significance of the left-hand Madonna as the Virgin in the Temple in the time before her betrothal to Joseph but also, and even more, the pictorial relationship between the two halves of the picture becomes more and more tenuous.[76] At the end there remain only simple designations for certain basic dualistic concepts such as *sponsa et mater* or *virgo et mater*, which yield nothing more in the way of pictorial contrast. The fact is, the right-hand Madonna is likewise surrounded by symbols of virginity, and both of them, the one on the right and the one on the left, are at one and the same time *virgo et mater*.

Reflected in all this is the way the entire body of iconographic motifs having to do with the Redemption developed in the fourteenth and fifteenth centuries. Devotional images were isolated from their narrative contexts and combined in allegorical relationships whereby they became pictures in which what was represented was not some specific incident but, instead, the generalized essence. However, the process was not reversible. The generalized image was not reincorporated into the narrative picture. There is no example of a picture in which the Virgin appears in the Temple wearing a crown and with a sunlike nimbus. In fact, such an image is not even possible, because the Coronation of the Madonna was the consequence not only of her virtues but also, and equally, of her merits in the service of the Redemption. For that reason we do not find a crown on or above the head of Mary until after the birth of Christ, that is, in pictures of the Holy Family or the Adoration of the Magi. Thus too the angelic concert cannot be associated with the "historical" scene of the Virgin in the Temple. If, however, one considers it as a generalized image of the essence of the Madonna, one is forced to surrender any notion that what we see in this picture can be consecutive moments of time within the story of the Saviour, because the "image of essence" is, by nature, an allegory beyond time. All attempts to assume a continuity in time in Grünewald's representation of the sacred story become, in the long run, entangled in this paradox. It is the crux of all exploration of the meaning of the middle picture with its two Madonnas.

The Mystical Birth of Christ

Since every attempt to interpret this central picture has run into insuperable difficulties, there can be only one conclusion: one must renounce all thought of an underlying scheme in which the left side of the picture is taken to be the expectation of the Incarnation, with Mary seen as a generalized, idealized figure in the Temple at Jerusalem, and the right side is considered as the fulfillment, the birth of Christ, set in a landscape abounding in symbols. The only feasible approach is to proceed from what is known—the two Madonnas and the clearly readable facts of their presentation—without any preconception that these pictures are based on a sequence in time, and from that basis to seek to arrive at some understanding of the relationships within the entire picture viewed as a whole.

We must begin with the small Madonna under the baldachin (colorplate, p. 42). She alone is distinguished by a transfiguring nimbus, one which furthermore is quite different from the aureoles of the spirits and angels around her. In consequence, she must be more closely related in significance to the Resurrection with its essentially similar gloriole. If, as we have seen, the nimbus of the resurrected Christ signifies His entry into the state of transfigured corporeality, then the small figure of Mary can only be read as likewise signifying a state of transfiguration. That state, however, according to medieval theological notions, was achieved only in her Assumption and subsequent Coronation as Queen of Heaven and of the Angels. By having been taken up into Heaven, Mary became the only human being to attain the ultimate stage of corporeal Transfiguration.

So what we have here must be some special iconographic form of the Coronation of the Virgin. The transfigured Madonna must be related to the one on the right in the same way as the Resurrection is related to the Annunciation. However, since in the central picture the transfigured Madonna and the "earthly" Madonna belong to one and the same pictorial entity, the former must be meant as a visionary manifestation. The Madonna under the baldachin must therefore be a vision perceived by the Madonna seated in the *hortus conclusus*.

This conception may appear surprising at first thought, entailing as it does a complete reversal of the relationship between the two figures that all previous interpretations have proposed. It is nevertheless an inescapable deduction from what we can see in the picture itself as well as from the difficulties that those previous attempts at interpretation encountered. What is more, it receives very significant support from the earliest description of the Isenheim Altarpiece, the *Anzeige* of Franz Lerse, a citizen of Strassburg who in his youth was a friend of Goethe.[77] Between 1777 and 1793 Lerse was in Isenheim and saw the altarpiece in its original setting when it was still the property of the Church. H. A. Schmid, who published Lerse's description, points out that it has a positive value as a source since it may well contain authentic information about the meaning of the altarpiece.

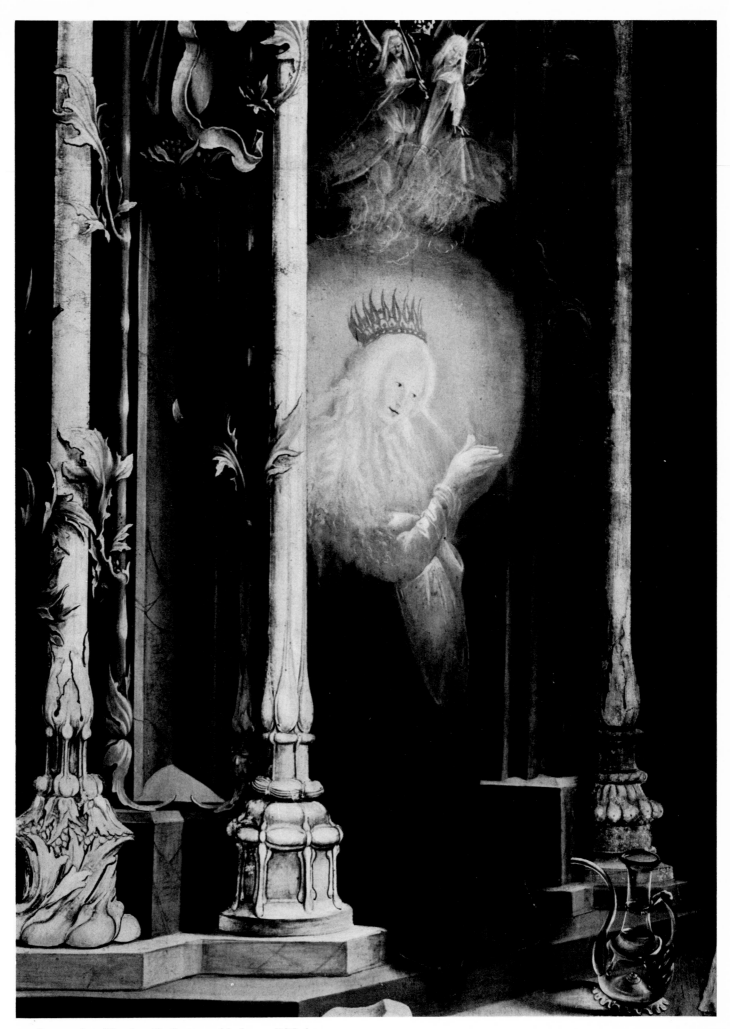

12 Incarnation: The Angelic Concert with the small Madonna

13 Incarnation: The large Madonna with the fig tree

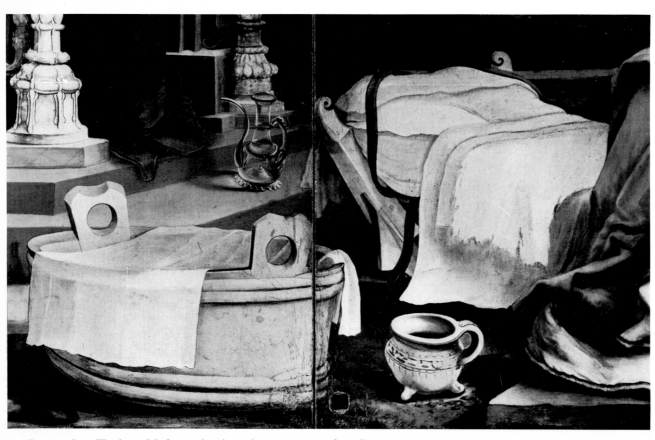

14 Incarnation: The large Madonna showing tub, cruet, pot, and cradle

divine course of the act of Redemption: in the *Annunciation,* the entry of the Son into human corporeality; in the *Resurrection,* His triumph, His entry into the new corporeality of the Transfiguration. In the central picture we see the Son become Man, now fully clothed in flesh (colorplate, pp. 24–25). But His birth is also the cause of the glory of His mother who therefore is portrayed in the middle, in double guise and framed by the beginning and the end of the divine way. For having given birth to the Son of God she is promised and awarded Transfiguration and Coronation. It is only in this context that the often-cited passage from Saint Bernard can be applied meaningfully: "You clad Him in your flesh and He clad you with the radiance of His majesty. You clad the sun with a cloud, and you were clad by the sun."[82] The "sun in the cloud" is the covering over of the Child by earthly substance through which the divine light can only glimmer faintly. The Madonna in the radiance of His majesty—"clad by the sun"—is the transfigured Mary of the vision, the Madonna who appears in Heaven as Queen of Angels and whose destiny is foretold by the Infant. Further, the conception of the landscape as Eden is organically connected with this same theological approach. To the glory of the human race, which fulfills itself in the glory of Mary, corresponds also the apocalyptic renewal of the world. Because the Saviour of the world has been born, Paradise is regained, the spiritual Eden of the New Adam, the Messianic realm of peace foretold in Isaiah 2:2–5 and Micah 4:1–4 with the "mountain of the house of the Lord . . . in the top of the mountains" as seen here in the background. On the new earth appears also the "new Jerusalem, coming down from God out of Heaven, prepared as a bride adorned for her husband" (Rev. 21:2). This bride is the Madonna clad in the sun and crowned Queen of Angels who is enclosed within the symbolic edifice of the new Temple of Solomon. Her appearance and promise are the fruit of the union of the human with the divine nature. For that reason, between her and the nativity scene there is a curtain, symbol in the Old Testament temple of the separation of the human from the divine and, since it has evidently been drawn back here, now signifying the cancellation of that separation in consequence of the new covenant.

This general theological content of the entire middle position of the altarpiece would have been perfectly familiar to the medieval observer. That the mystery of the Incarnation and the Redemption consisted in the Assumption into Heaven of the transfigured corporeality of Christ and Mary, as well as in the spiritual re-creation of the world and of a New Eden, was among the basic postulates of all medieval theology but especially that of the mystics. It is this theological point of view that determines the artistic structure of the entire middle position of the Isenheim Altarpiece, of the *Annunciation* and the *Resurrection* on the wings as well as the alliance in the main picture of two such heterogeneous scenes within a single pictorial plane.

Yet, with all of this, we have discovered no more than a basic theological armature which still tells us all too little about the more detailed aspects of this unusual representation. Looking closer at Grünewald's picture, everything in it seems wholly at odds with what can be expected in a Madonna in a paradisiacal landscape and in a Coronation of the Virgin. Certainly no one will deny a certain resemblance between the right-hand Madonna and Dürer's Madonnas in open-air settings. The wall of the *hortus conclusus* dropping off as if in steps, the garden door with its cross-beamed props, the landscape with its body of water and its mountains in the background, the apparition of God the Father in the sky above the Madonna, and finally the pose of the Infant and the majestic and solemn way the Madonna's mantle is draped around her, all of this recalls similar motifs in Dürer's early copperplate engraving of the *Virgin with the Dragonfly* (fig. 27). In the drawing for the *Madonna with Several Animals,* Dürer further expanded the paradisiacal background into a setting for a Nativity picture: on a mountain slope shepherds receive the good tidings while from afar comes the company of the three kings (fig. 28). In his landscape Grünewald too shows the announcement to the shepherds (colorplate, p. 45). But one cannot help thinking that neither the gigantic figures of these shepherds, so transparent that the landscape can be seen through them, nor their sheep grazing on such a distant hillside were part of the original design of the picture and that they must have been added in a final revision, made necessary perhaps by some thoroughgoing change in the initial conception.[83] Other unusual details include the abbey on the mountainside and, above all, the furnishings of the lying-in room which have been brought out into the garden and are completely out of place if what is depicted is meant to be the Nativity.

In like fashion, neither the Coronation of the Madonna with a fiery crown nor her attendants over whom soar enigmatic figures in a blue aureole are found in other depictions of the Madonna in Heaven. If nevertheless one considers all this as belonging to a single consistent pictorial conception—and, the fact is, one cannot do otherwise—then the theological content we have been examining would seem to have been viewed through some special sort of prism because, in the final analysis, the representation does break down into a spectrum of highly unconventional motifs.

To find this special point of view, both halves of the picture must be examined once again, this time by proceeding from their details.

If we begin by considering the central focus of meaning in the picture, the Madonna in a landscape contemplating the Redeemer of the World, the question arises as to whether the details surrounding her are associated with this funda-

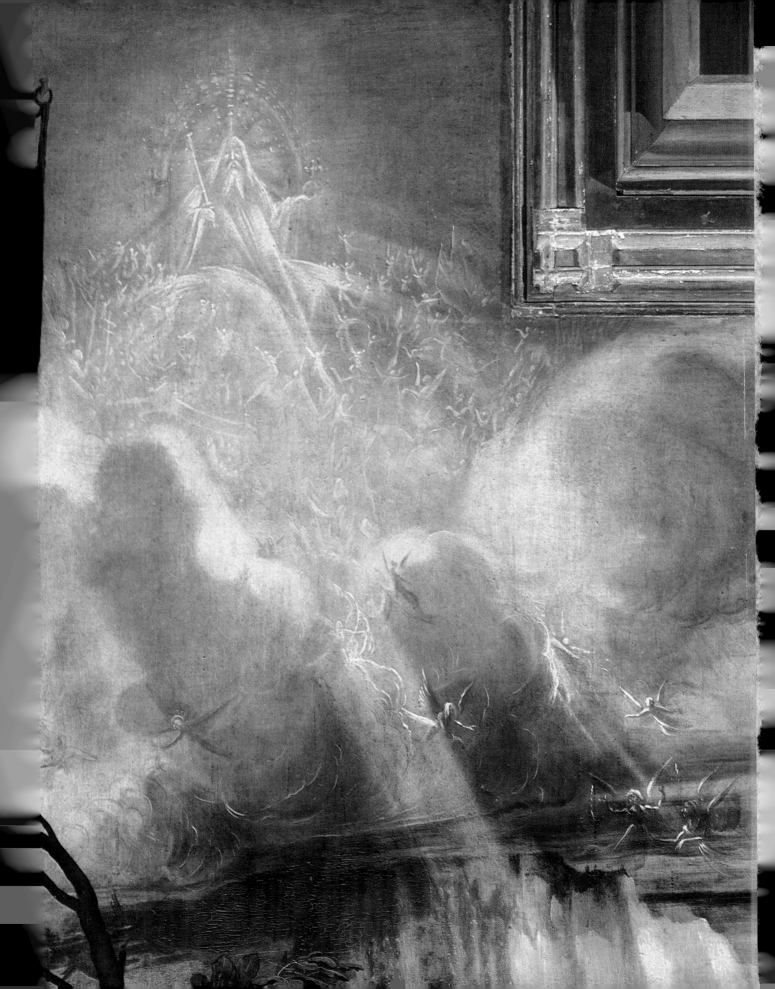

mental theme and, if so, to what extent (colorplate, p. 45).

In the Madonna's immediate vicinity are motifs allegorical of her virgin motherhood. At her right, close by the pond, is the *rosa mystica* spoken of in Ecclesiasticus 24:14 and celebrated in the offertory of the seventh-century Mass of the Most Holy Rosary: "Ego quasi rosa plantata super rivos aquarum fructificavi." (Like a rose planted on the rivers I have borne fruit.)

Then, behind her is the familiar symbol of virginity inviolate, the *hortus conclusus*, the closed garden. Likewise the Venetian-glass cruet on the steps of the baldachin, filled with wine and pierced through by sunlight, has always been recognized as an allusion to the virgin motherhood.[84] The fig tree to the left of the Madonna expresses the same meaning, because in the East it is taken as a symbol of parthenogenesis, being thought to produce fruit without fertilization of its blossoms. The notion reached the West by way of Saint Augustine's comparison of the Madonna with the fig tree since, in both, blossom and fruit, virginity and motherhood are the same.

These symbolic allusions are familiar from the traditional Mariology. Not so, however, the objects belonging to the lying-in room—the cradle, tub, and pot—which lie scattered around the Madonna and are represented on the same scale as her figure (fig. 14). These do not belong to the iconography of the birth of Christ but rather to the conventional depictions of the birth of Mary or of some saint, but even then those episodes are never set in an open landscape. Here therefore they cannot pertain to any such scene. Rather they are associated—as motif or general theme—with the contemplative practice in the monasteries, most notably in the women's convents in the late Middle Ages where the nuns had their Christ Child dolls which they put to bed in cradles and washed in tubs.[85] Ever since the early Middle Ages this practice served to aid the nuns in their contemplation, to set the Incarnation before their mind's eye. It was already incorporated into Franciscan mysticism by the beginning of the fourteenth century, since in the *Arbor vitae*[86] of Ubertino da Casale we read:

Est scilicet in te natus parvulus Jesus:
Involvendus,
Reclinandus,
Custodiendus,
Levandus,
Lavandus,
Deducendus,
Et cibandus

meaning, "The Child Jesus born in thee [in contemplation] must be swaddled, laid in the cradle, sheltered, lifted out, bathed, taken, and eaten," the latter referring to the sacramental and mystical union in the Eucharist.

Now, the tasks of the Madonna as mother comprise all those activities encouraged in the mystical contemplative practice: swaddling, laying down and sheltering the Babe in the cradle, bathing Him, taking Him up in mystic union. In consequence, the introduction into the picture of the paraphernalia of the lying-in room signifies the mystic act of veneration of Christ's corporeality.

The birth of God through contemplation is one of the central tenets of mystic theology.[87] As an example of this general Augustinian train of thought can be cited a text like the sermon on the Ave Maria by Meister Eckhart (c. 1260–c. 1328): "I spake: and had Mary not borne God in her spirit, He would never have been born from her in the flesh."

But why is all this in the open air, in a landscape? Because the landscape too is related to the contemplative birth, being an allegory in a special form. Along with the scene of the tidings brought to the shepherds, the mountain landscape includes not a city, the New Zion, as in Dürer's Madonnas in a paradisiac setting but, instead, a monastery (colorplate p. 45).

The building was first assumed to be among those connected with the Anthonite order. But it is neither their monastery in Isenheim nor the ones in Murbach or Bingen. So far it remains unidentified, and it is questionable if it ever will be. But even should a name be attached to it some day, within this paradise-garden landscape it would still stand for the New Zion, but in the special sense in which every monastery is considered to constitute a New Zion. The notion goes back to Anthony himself who described monks as new angels in the New Zion,[88] an idea often echoed throughout the Middle Ages. In Western depictions of the anchoritic landscape such as the so-called Thebaids, a hermitage or monastery is always prominently featured. Pictures of Anthony meditating in the "blossoming desert" show it as a rule, as do those of Jerome in his rocky refuge. The notion is particularly evident in Dürer's woodcut of *Saint Jerome in a Cave* (B. 113) of 1512, with its distant view of a monastery along the body of water below the saint's mountain of meditation.

The idea is reflected, moreover, in the sites chosen for monasteries in the West. Obvious reminiscence of the paradise-landscapes of the desert fathers, the early foundations of the Benedictines and other orders, in Italy especially, were located by preference on a mountainside. The thought behind this was quite certainly the same as that which in the first place suggested the landscape as a symbolic concept into which the hermit was to fit himself, except that now one has the monastery rather than the cave. The symbolic Paradise is now the monastery itself from which the mystical Jacob's Ladder of contemplation rises, as mentioned specifically in the Benedictine Rule.[89] Here, with as much right as in the patristic literature, one may speak of an Occidental landscape of the *vita contemplativa*.[90]

The mystical birth of God from a Virgin who is shown

surrounded by the allegories of her virgin motherhood within a landscape bearing the inner significance of the *vita contemplativa*, thus resolves itself into an entirely unified and consistent pictorial content. As in all the literature of mysticism, here, too, Mary is portrayed as the foremost exponent of the monastic life, and this is why she is represented in an allegorical landscape in which everything concurs to express this aspect.

The Coronation of the Virgin by the Angels

Similarly, the Madonna under the baldachin diverges from the standard iconographical type of the Coronation of the Virgin. Certainly the imperial crown held over her head by angels is without question the crown of the Queen of Heaven. Likewise her yellow and red nimbus of light, by analogy with that of Christ in the *Resurrection*, can only be a nimbus specifically denoting Transfiguration. But the glowing crown she wears is something iconographically unique and constitutes, in effect, the crux of any interpretation of the altarpiece as a whole (colorplate, p. 42). To dismiss it as merely another arbitrary modification of a motif on the part of Grünewald explains nothing. Nor can anyone who looks twice be satisfied with the often expressed notion that this is no more than a leaf-crown pure and simple which has taken on a red glow from the nimbus. Admittedly it is similar in form to that kind of crown, but it is composed of nothing more tangible than red and yellow light, and there is no way of getting around the fact that it is some sort of flamelike object. Nor, finally, can it be overlooked that one of the participants in the angelic concert, the angel soaring aloft in a blue aureole, likewise wears a diadem which quite definitely gives off light (fig. 10).

As a prototype for this pictorial image there was obviously some Coronation of the Virgin with a very special point of view, one which also was meaningful theologically in relation to the general idea behind the entire middle position of the altarpiece. It so happens that there is, in fact, a literary source which sets before us precisely this special form of the Coronation within a gloriole. This is how Dante describes the Triumph of Christ and the crowning with flames of the Madonna in the Heaven of the Fixed Stars (*Paradiso*, XXIII):

But swiftly did the space of time transpire 16
 Between my waiting and beholding how
 The heaven was lit with ever brighter fire.
Then she: "Behold Christ's hosts in triumph! Thou 19
 Mayst see the fruit all garnered here above
 Which 'neath these circling stars matured ere now."
To me her face seemed all aglow with love; 22
 And in her eyes such joyousness was seen

I cannot tell of it, but onward move.
As, when the moon is full, the night serene, 25
 Trivia smiles mid nymphs eternal, who
 Silver all heaven, to its last demesne,
Outshining myriad lamps, One Sun I knew 28
 Which kindled all the rest, even as our sun
 Lights the celestial pageantry we view.
And through the living radiance there shone 31
 The shining Substance, bright, and to such end
 Full in my face, my vision was undone.

 · · ·

As when the sky, oershadowed, formed a shield, 79
 'Neath which the unsullied sunlight once I spied
 Streaming through cloud-rifts on a flowery field,
So countless thronging splendours I descried, 82
 Ablaze with shafts of lightning from on high,
 Yet saw no founthead to this blazing tide.
O power benign, whose seal on them doth lie 85
 So clearly, thou, to enlarge my vision, didst raise
 Thyself aloft, sparing these eyes thereby.
The sound of that sweet flower's name, whose praise 88
 Morning and eve I sing, my whole soul drew,
 And on that fire of fires led me to gaze.
When, imaged upon both mine eyes, I knew 91
 The size and brilliance of that living star,
 Who, as on Earth, in Heaven rules anew,
Sped from beyond that sphere, a flammifer 94
 Ringed her about, spinning itself around,
 Weaving a circle like a crown for her.
The sweetest melody that e'er did sound 97
 In mortal ears, stealing the soul away,
 Like thunder bursting from a cloud were found
If matched beside that lyre's roundelay 100
 Ringing the sapphire, whence, ensapphirined,
 The brightest sphere of heaven was made more gay.
"Of the angelic loves am I, and wind 103
 Circling the joy sublime breathed from the womb
 Where once abode our hope for all mankind.
Still circling, heavenly Lady, will I come, 106
 Till with thy holy presence thou hast filled,
 In thy Son's wake, the sphere which is thy home."
Thus the entwining melody was sealed. 109
 All other lights together cried aloud
 And through the sphere the name of Mary pealed.

 · · ·

Then still within my sight they lingered, singing 127
 Regina coeli with such dulcet sound
 Within me still the joy of it is ringing.
From Saturn, the planet of the *vita contemplativa*, Dante has reached the Heaven of the Fixed Stars which, in Dante's cosmogony, receives the light of God in as yet undivided form and then apportions it to the individual human soul-

conception is, of necessity, part of a context other than Dante's poem where it belongs to the poet's vision of Paradise in which the triumphant risen Christ is equated with the sun and the Madonna with the *virgo caelestis*, the constellation of Virgo, a notion that can also be found commonly in depictions of the zodiac, where one likewise often finds the Angel of Annunciation shown alongside the Queen of Heaven. In the German late-medieval *Marienleben*, when Mary reaches the highest of the angelic choirs in the course of her Assumption into Heaven, she is greeted once more by the Angel Gabriel with the same words spoken in the Annunciation. In Dante's poem likewise, Gabriel escorts the Virgin into the Empyrean. Gabriel is himself elevated above the ranks of the angels and is henceforth bound to the Virgin in a kind of *annuntiatio aeterna*. This is why occasionally one finds pictorial representations in which the Annunciation is set up in the sky in place of the constellation Virgo. The Coronation of Mary by the Angel Gabriel in the form of a crown of flame may perhaps be Dante's own poetic invention, but it certainly derives from late-medieval literary sources in which the celestial Mary is accompanied by the Angel of Annunciation and is characterized as Queen of Angels.

In the Isenheim Altarpiece, the Coronation by the angels is interpolated into the sequence of scenes of the Passion and Redemption and is therefore set in its own symbolic space, the celestial *templum Salomonis*. The relationship thereby set up between the angelic Coronation in Heaven and the Annunciation on earth seems to be the basis for Grünewald's having gone back to an older form of representation of the Annunciation in which Mary is shown in a symbolic edifice of great splendor. Similarly, in the late-medieval illustrations for printed editions of the *Divina Commedia*, in Canto XXIII of *Paradiso*, not the Madonna but her symbolic equivalent is shown, a religious edifice appearing in the sky and surrounded by rays of light.[91]

Thus, on the basis of the contemplative *imitatio Christi*, it is possible to arrive at some sort of definition of the theological content of the middle position of the altarpiece. In two contemplative acts performed by Mary, the glory of the *gens humana* is brought into experience: in the contemplation of the passage from Isaiah she learns of her role in the Incarnation of Christ, in contemplating the Redeemer become Man she has a vision of her own Transfiguration and her Coronation as Queen of Angels and of Heaven. The setting is the symbolic landscape of the *vita contemplativa* with the monastery on the mountainside and, down below, the *templum Salomonis* rebuilt in the New Jerusalem. Here, we can be sure, is an allusion to the widespread belief, intimated already by Anthony himself, that after the fall of the rebel angels the ranks of the angels of Heaven were replenished with monks.

It is clear that the angelic coronation is rendered by Grünewald in the special form recorded in Canto XXIII of Dante's *Paradiso*. However, from that source we learn nothing about the individual components of Mary's escort, the so-called angelic concert, other than the generalization that it is made up of angels and saints. Whether the large and small angels were intended by Grünewald to typify specific angelic hierarchies remains an open question. The feathered angel with the crownlike headdress who gazes upward toward the angel Gabriel is probably meant to be one of the cherubim (fig. 11). Most likely the figures without wings should be thought of as adherents of the Anthonite Order. Here, however, all interpretation that does not wish to fall back on pure speculation must come to a halt.

Not even the subject matter of the tympanum relief on the baldachin can be determined with any certainty (fig. 9). One can make out some sort of figure without a halo who kneels in a pose suggesting petition before an enthroned and haloed figure whose left hand is raised as if in blessing. If the kneeling figure is a prophet or patriarch, then the one enthroned can only be God the Father. More likely, however, the personage on the throne is meant as Saint Anthony from whom the sponsor of the altarpiece, Guido Guersi is, shown imploring a blessing on his work.

THE CLOSED POSITION

The Crucifixion

When the movable wings are closed, the *Crucifixion* covers over the glory of the *gens humana* like a dark curtain (colorplate, p. 7). In a sense we have here a kind of summary of the entire structure of the altarpiece, the union of the life of Christ with the stories of His saints. The central event of the Passion, the Crucifixion, is flanked by two saints, Sebastian and Anthony the Hermit. Such juxtapositions are common in altarpieces with side wings, and the *Crucifixion* itself does not deny its origin from monumental devotional images, from those depictions of the Crucifixion which do not present the scene on Golgotha with a swarm of figures but instead confine it to the *Passio*, that is, Christ on the Cross, and the *Compassio*, the grief of the Madonna and of those closest to Christ.

The portrayal of Christ's frightful martyrdom and lonely death in pain, intensified here into something atrocious, would be comprehensible in both human and artistic terms as a nerve-shattering appeal to the viewer. Here, though, it is further elevated into a special context by the powerful figure of John the Baptist who stands at the other side of the Cross in superhuman imperturbability, not looking down at the Lamb of God at his feet but, instead, pointing to the

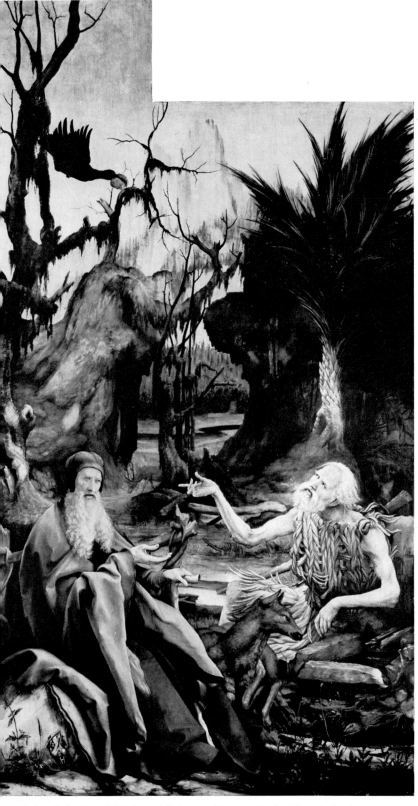

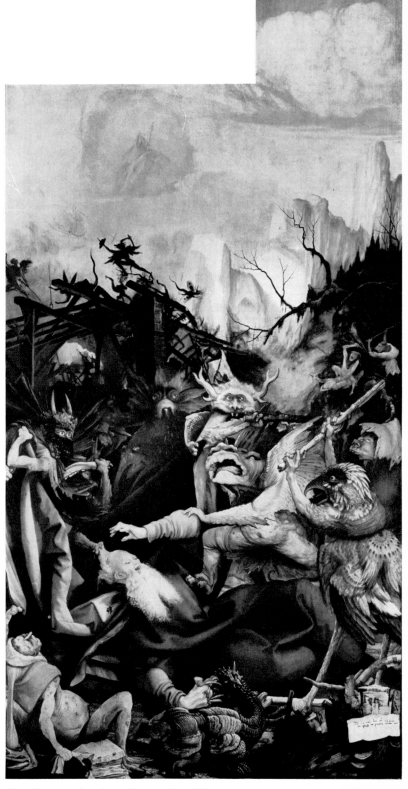

15 Shrine, left wing: Meeting of Saint Anthony with the Hermit Paul

16 Shrine, right wing: Temptation of Saint Anthony

17 The Meeting: Landscape

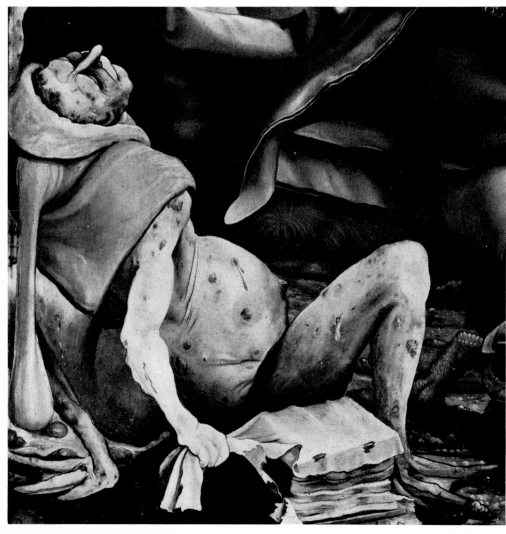

18 The Temptation: Web-footed demon

crucified Christ in a gesture which is accompanied by the words: He must increase, but I must decrease.

The contribution of the *Crucifixion* to the theological substance of the altarpiece as a whole must consequently reside in the fact that the *Passio* and the *Compassio*, fraught with tension and raised to a point of extreme exaggeration, are juxtaposed to the dictum of the Baptist, a most unusual combination of ideas. Various explanations have been proposed.

It has been said that, over and beyond the achievement of the artist's personal genius, in this picture of the Passion, the theological program had no more than a simple didactic or symbolic schema to offer. Some writers reduce this to a formula, like that which they attempt to foist on the *Incarnation* of the middle position. The mystery of the Redemption is considered as the midpoint between the Old and the New Testaments. Thus, like the *Incarnation*, the *Crucifixion* too would be a picture of a specific event in a specific moment of history, differing only in that here the Old Testament allusion appears on the side opposite to that it is said to hold in that other problematic picture. Here the representative of the Old Testament, the last prophet of the age which "points the way" is John the Baptist.[92]

Other writers say the content is to be understood more in terms of a dogma based on contrasting aspects.[93] Thus, while the Crucifixion itself is shown with frightful clarity as a bloody sacrificial death, these writers say that the symbol of the Lamb indicates the unbloody sacrifice of Redemption, the Mass. It is also claimed that there was a confrontation between the event, which occurred only once in history, and the act of Redemption which is superhistorical and eternal. This notion of a double-Passion is said to be expressed in the wings also: on the left, Sebastian the blood-martyr, on the right, Anthony whose sacrifice was bloodless. In any case, this interpretation must be rejected as inadequate because it makes no attempt to clarify the important motif of the Baptist's pointing gesture.

Feigel attempted to find some deeper ground for the presence of John the Baptist in such a gruesome picture of the Crucifixion.[94] For him the Baptist is the great preacher of repentance: "the frightfulness of sin is brought to the consciousness of the faithful with so much greater impressiveness . . . the more ghastly appears the Atonement that Christ of His free will took on Himself." The sinner must therefore become small—"me autem minui"—and God assume full reign: "illum oportet crescere." However, while this interpretation may offer some theologically possible basis for the extreme depiction of suffering, it remains dubious that John the Baptist can be taken as spokesman for sinners.

By approaching the problem from another standpoint, recent research has come up with important new insights into the meaning of the picture. Feurstein's interpretation takes into account the traditional iconographical significance of the two saints on the side wings.[95] Both figure among the saints who are helpers in need, both are highly venerated as protectors against illness, and they are often shown together as patrons of the sick. Since the Anthonites were hospitalers, that is, monks concerned with the care of the sick, the significance of the presence of the two saints here is obvious. For his part, Zülch finds in the Anthonites' dealings with the sick the key to the meaning of the entire ensemble.[96] In hope of a miraculous cure, seriously ill persons, who were called "God's little martyrs" in mystical analogy to the divine flesh, were brought to the Anthonites. For that reason, one finds associated with Christ's sacrificial death four Holy Helpers in Need, the four saints who often appeared together on the pilgrims' devotional prints of the Anthonites: Anthony against Saint Anthony's Fire, Sebastian against the plague, John the Baptist and John the Evangelist against epilepsy.

Obvious as is this connection with medical matters, it nevertheless does not offer full clarification of the meaning of the painting. The two Johns are actively involved in the scene of the Crucifixion. The Baptist "speaks" a text which does not in itself say anything about his significance as a helper in need. Further, the two saints on the wings are characterized in a manner which goes well beyond their role as patrons of the sick. They are, to the contrary, portrayed as triumphing over Evil.

Furthermore, in Zülch's interpretation the inner relationship of religious therapy to such an extreme depiction of suffering and death remains unclear, unless we are to assume that it involved some sort of brutal shock-effect.

In any event, in late-medieval art the depiction of extreme suffering was motivated not by psychology but by theology. Especially as thought of by the mystics, the participation of Christ's divine nature in the suffering of the Passion surpassed all human measure. Excess, disdain for limits, replacement of all natural standards of proportion by ratios based only on boundless feeling, it is these that lie at the core of mystical exegesis and compel art to have recourse to a language of superlatives.

Grünewald was not the first artist to acquiesce in such an attitude. One finds it already, and in no less extreme guise, in the so-called plague or mystic crucifixes of the first years of the fourteenth century, such as the famous one in the capitulary hall of the women's convent in Saint Maria im Kapitol in Cologne (fig. 22), where a frightful, pitiable body of Christ hangs helpless, laden with a kind of total martyrdom which makes of the God-Man—wasted, ugly, utterly defeated—the object of supreme compassion.

Nevertheless, for all that they have a common basis in theology, a comparison with Grünewald's crucified Christ shows that it belongs to a quite different type. Before the giant

of the Isenheim Altarpiece stretched in pain, mere compassion is without avail. Consternation, awesome power, majesty are what this figure expresses.

This disparity in fundamental conception can be observed also in the text adduced by Feurstein in support of his thesis and which does, admittedly, seem startlingly relevant at first reading. In Book Four of her *Revelations*, Saint Bridget of Sweden places in the mouth of Mary herself a description of the crucified Christ as realistic as Grünewald's portrayal, and indeed certain passages do read almost like an account of the Isenheim *Crucifixion*.[97] There is mention of the crown of thorns "hanging halfway over the face," of the "pallor of death," of the belly drawn taut, the beard pressed against the chest, the mouth dropped open, the feet "twisted to the opposite side as if the nails through them were door hinges." Feurstein is convinced that these words were "quite obviously directly translated into the language of painting." Now, anyone wishing to assume such a close link must first make certain that the description and the picture really do match that closely in major aspects as well as details. That happens not to be the case here. Bridget is clearly describing a form of crucifix of which she must have known many examples but which is markedly different from Grünewald's. Hers is the type on which the body of Christ hangs limply, covered with blood: "... so that the whole looked to be almost no more than a river of blood ... the already dead body hung down ... the knees were bent to one side." In this type the body hangs slackly with knees pulled to one side; in the fourteenth century it was common everywhere.[98]

But Grünewald's crucified Christ does not hang limply. He is jerked up high, stretched by the crossbeam like a victim on the rack, all extremities strained to the utmost, joints dislocated (fig. 5). The nail wounds cause huge swellings to come up on the underside of the feet (fig. 6). This conception of crucifixion as the stretching of a body on the rack—the most frightful of all medieval tortures because every member and not only the surfaces of the body had to endure pain—plays a role in the writings of Saint Bonaventura above all, in his exegesis of the sufferings of the God-Man.

The fact is, the real source for Grünewald's picture is in the writings of Bonaventura. There it is said that Christ's suffering is the most ignominious, the bitterest, the most all-embracing.[99] That is why every member of His body had to endure it, and this could only be on the rack, stretched in torture which "prevented the holy members of His body from drawing together in the pain of death" (Bonaventura, *The Perfect Life*, Chap. 6:5), and with all of the flesh covered with wounds. "The more all-embracing a suffering is, the greater it is as well. Christ, however, our soul's bridegroom, suffered in all parts of His most holy body and, indeed, in such a manner that each individual member was forced to endure its own separate suffering. There was no place on his

body not ravaged by torments. From the soles of His feet to the crown of His head, no spot on Him was left hale" (Bonaventura, Chap. 6:6).

Despite all the extremes of suffering, the Christ stretched on the Cross does not give way in death but, instead, perdures, triumphs. The understanding of this conception is beyond the grasp of mere compassion but can be reached by theological contemplation, and in consequence has led to special efforts to depict it in terms of coexperience, of the imagined sharing of the martyrdom.

In Grünewald's picture this aspect is expressed in the magnificent portrayal of the *Compassio*, the "cosuffering" of the Madonna, John the Evangelist, and the Magdalene (colorplate, p. 21). The *Compassio* is a theme frequently exploited by the visual arts, and it offered a rich imaginative vein to medieval theology and poetry.[100] The Gospels say nothing about it, and only Simeon's prophesy, "Yea, a sword shall pierce through thy own soul also" (Luke 2:35), can be connected with the suffering of the Virgin. During the many centuries of the Middle Ages the religious imagination gave full expression to Mary's suffering at the Cross, above all in its dual aspect, as *lamentatio* (mourning) and as *agonia* (her swoon of grief). In the *lamentatio* Mary wrings her hands, cries out her grief to the bystanders and to all mankind. However, in the Isenheim *Crucifixion* only the disciple John and Mary Magdalene are depicted in *lamentatio*, while Mary is wholly given over to her *agonia*. This agony has always been interpreted as equivalent to the *Compassio*, as the Passion and death of Christ experienced in empathy: "Ibi agonia, ibi dolor, ibi mors morte durior," wrote Amedeus of Lausanne who died in 1159.[101] In mystical contemplation it is intensified to become an ecstatic swooning. This corresponds to the widespread tendency in the late-medieval monasteries to comprehend the *imitatio Christi* as a contemplative experience: "To the extent of my powers, to become in spirit and in contemplation that which Thou wert in the flesh," is the way Heinrich Suso expressed it.[102] In Grünewald's painting too then it is a matter of theological contemplative experience, and this is given its clearest expression in the fact that Mary is dressed as a nun, thus making of her the representative or advocate of those who choose the monastic life.[103]

In her posture and visage Grünewald gave unequivocal expression to the concept of ecstatic surrender. It cannot be by chance that in the Isenheim Altarpiece wherever Mary appears in an episode of the sacred story she is portrayed in a state of contemplative introspection, of self-absorption. Rather it is an unmistakable assertion of the idea that the acts of that story are not only "events" but also prime motivators of the mystical contact with the Divine.

The figure of John the Baptist fits into this same context. His customary attribute, the Mystic Lamb with the chalice

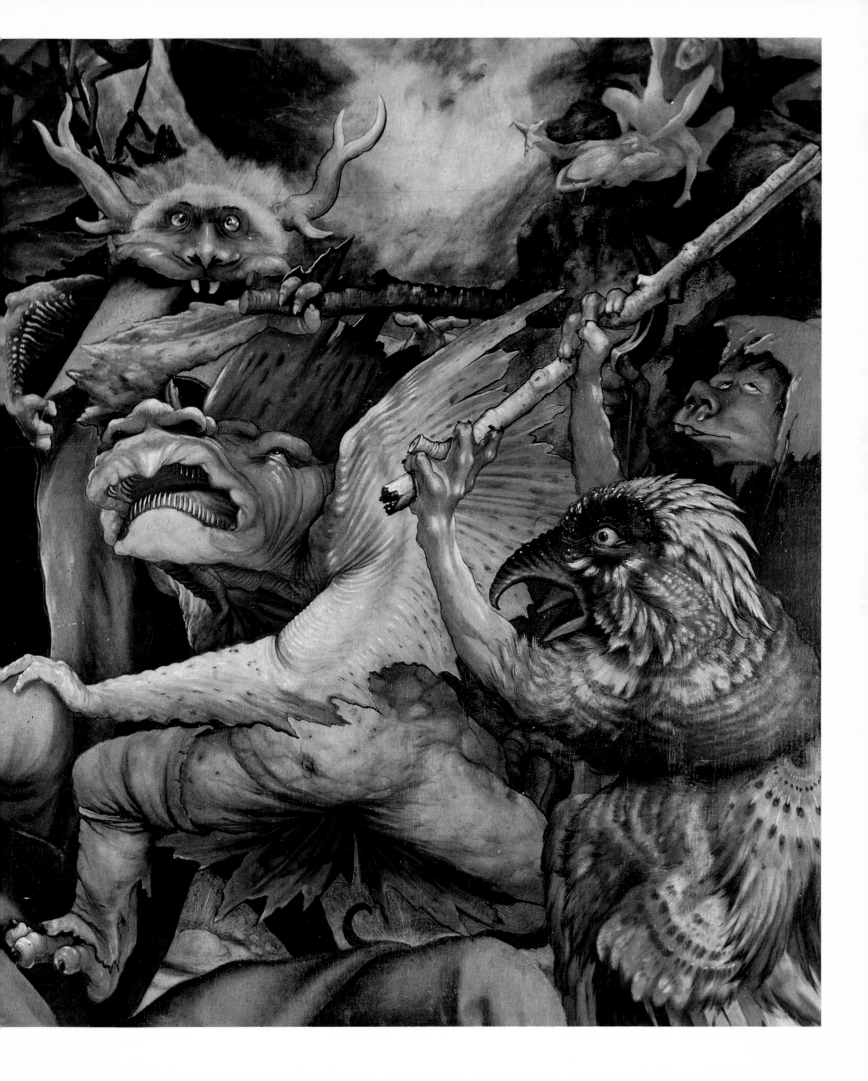

into which its blood streams, alludes to the Passion itself, to Christ as expiatory sacrifice and as source of the sacramental grace, in accord with John 1:29: "Behold the Lamb of God, which taketh away the sin of the world" (fig. 4). Why, however, does the Baptist point to the crucified Christ, and why is this gesture accompanied by an inscription which refers to the Baptist himself: "He must increase, but I must decrease"? The words are used in the Gospel according to John in a specific context. After he had baptized Jesus, John the Baptist was questioned by his disciples about his relationship to the holy stranger, and he replied: "Ye yourselves bear me witness, that I said, I am not the Christ, but that I am sent before him. He that hath the bride is the bridegroom: but the friend of the bridegroom, which standeth and heareth him, rejoiceth greatly because of the bridegroom's voice: this my joy therefore is fulfilled. He must increase, but I must decrease" (John 3:28–30).

The meaning is then: the more the true Christ advances, by that much must I retreat. But what can this mean in connection with the dead and martyred Christ? Why must He grow, what of Him is to grow? Karl Sohm believes that the Baptist's allusion is explained by the comparison with the "friend of the bridegroom,"[104] relating it to the "marriage of the Lamb" in Revelation 19:7 which says "the marriage of the Lamb is come, and his wife hath made herself ready." The Baptist would therefore stand next to the Cross as witness for the blood wedding of the Lamb. But since it is not this Biblical passage which is cited in the picture, Sohm finds himself constrained to relate the painted dictum once again to the relationship between the Old and the New Testaments.

There is, however, a medieval exegesis on the dictum itself which leads in an entirely different direction. The *crescere*, the "growing" of God, is a specific theological concept which expresses the idea of the Passion of Christ as a triumph. Saint Bernard of Clairvaux put it thus: "Because of His divine nature Christ could neither increase nor rise higher, since beyond God there is nothing. And yet by His descent on to earth He found nevertheless a means of growing yet more. He came to become man, to suffer and to die.... For which God elevated [increased] Him, for He rose up, ascended into Heaven, and is enthroned at the right hand of God. Go thou and do likewise."[105] Thus God Himself grew through having become Man, through suffering and dying, because in His Transfiguration He elevated and absorbed what is human.

The "minui," the decrease, is likewise given a specific meaning by Bernard: "Persevere therefore, dearly beloved, in the monastic discipline you have taken upon you, so that, by means of this great humiliation, you may finally rise to the heights." Here the "decrease" signifies the monastic *ascesis* and *humilitas*, the fundamental conditions of the ascetic way of life. In accord with this, then, John the Baptist is included in Grünewald's picture as the first anchorite, and in fact throughout the Middle Ages he was so celebrated, and by no one more than by Saint Benedict of Nursia.[106]

For this interpretation yet another allusion seems to speak: the immense landscape that forms the background for the Crucifixion (colorplate, p. 7). From the arid stony ground where no plant grows, the summit of Mount Golgotha where the Cross stands, the landscape sweeps out in a vast valley of startling void and darkness, marked only by the city of Jerusalem, all the way to the silhouette of the far-distant mountains. If one of the sources of Grünewald's depiction of the Crucifixion is, quite rightly, taken to be the passage referring to the "servant of God" in Isaiah 53:2— "He hath no form nor comeliness; and when we shall see him, there is no beauty that we should desire him"—then a specific concept of landscape goes along with this.[107] The same verse says, "For he shall grow up before him as a tender plant, and as a root out of a dry ground." The expression "a dry ground" goes back directly to the "waste places of Jerusalem" (Isa. 52:9) and to the "dry wasteland" (Isa. 34:11–15) which play a role as symbolic prototype in the *Vita B. Antonii*. This is the wasteland, the desert which the anchorite traverses in the first stage of his journey through life, as illustrated in the so-called *Temptation of Saint Anthony*. Thus in Grünewald's picture the Baptist stands in the landscape that belongs to him as "the voice of one crying in the wilderness," and so the Crucifixion too is set in a symbolic landscape which alludes to the *vita contemplativa*.

Below the *Crucifixion* is pictured the lowest point of Christ's descent into human form, the *Lamentation* (colorplate, p. 7). Here too the source is not Biblical, the episode being among those that the devout imagination has invented and interpolated into the Passion story, between the Deposition from the Cross and the Entombment, and in the cycles of pictures on the Passion it is always clearly differentiated from those episodes. The dead body of Christ, removed from the Cross but not as yet wrapped in the burial shroud, is raised up slightly by John to receive the veneration of the mourning women. Mary, her grief now quieter and as if exhausted, gazes in contemplation at what is no longer a body enduring an excess of suffering but, rather, one which is already being transformed in preparation for the Resurrection. The flesh has changed from the discoloration of dreadful agony to the gentler pallor of a cadaver which soon, in the *Resurrection*, will take on the illumination of Transfiguration. This "differentness" of the Christ in the *Lamentation* has often been singled out as something remarkable. It is, in fact, an indispensable and unifying motif for the entire altarpiece. It alone makes it possible for this same predella to appear again below the pictures of the middle position with their images of glory.

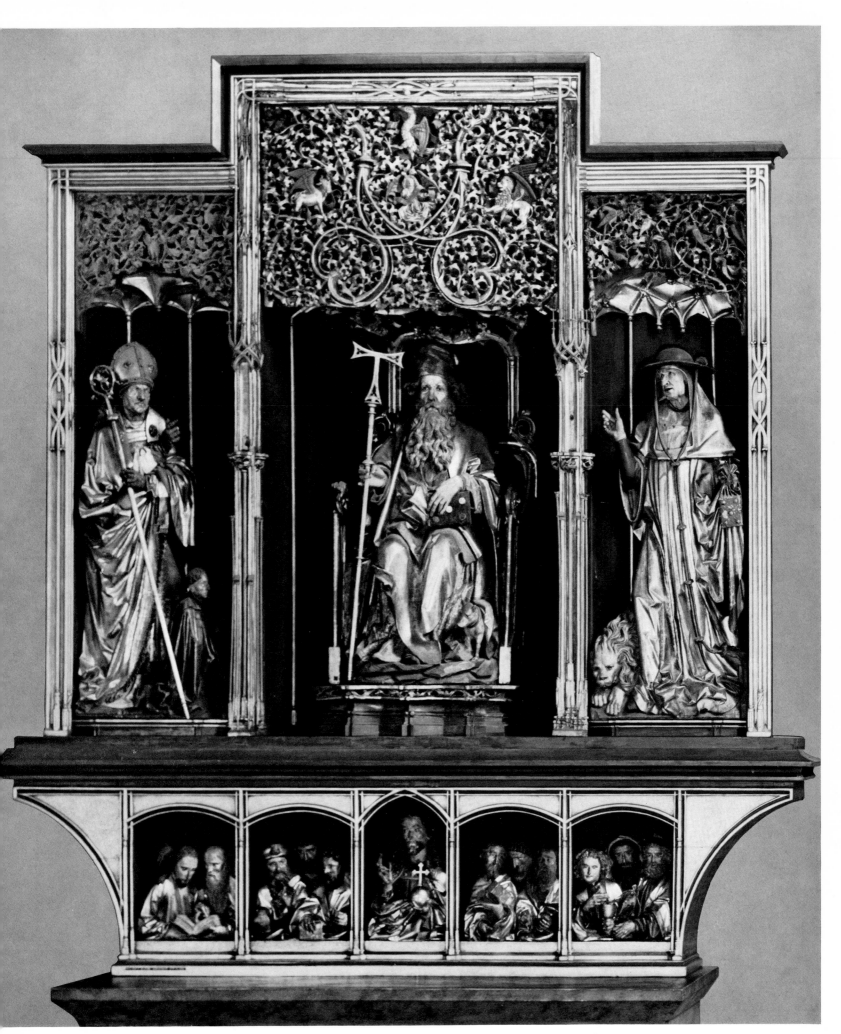

Shrine: SS. Augustine, Anthony, and Jerome. Below, Christ with the Twelve Apostles (predella has modern framework)

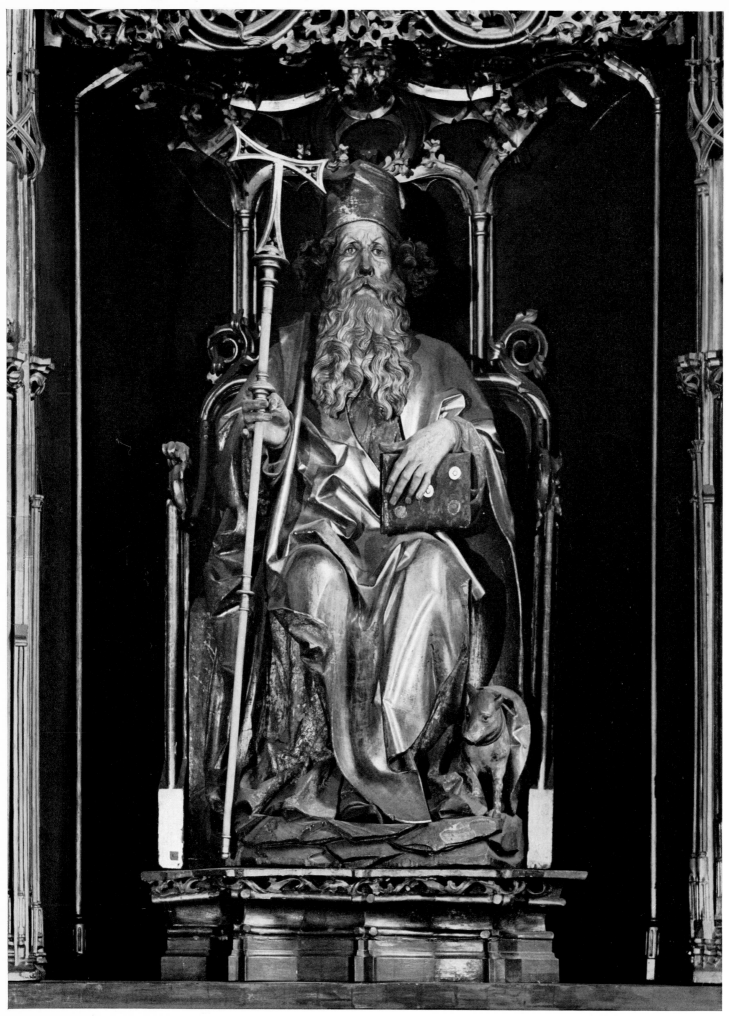

20 Shrine: Saint Anthony as abbot

The Program as a Whole

Once the content of each of the three ensembles has been clarified, the overall theological program of the altarpiece can be seen to constitute a homogeneous and coherent train of thought.

The basic theme is the inner correspondence between the *vita contemplativa* and the *vita Christi*. Both are shown in their two mutually interacting stages, the lower stage which is suffering, the higher stage which is glory.

As the legendary founder of the *vita contemplativa*, Anthony the Hermit is awarded the central place in the ensemble with the carved shrine, where he is attended by the Doctors of the Church and the Evangelists as witnesses to the truth. The two main phases of his anchoritic way are represented on the wings: on the right the so-called *Temptation* or, more correctly, the testing of his *humilitas*, on the left his meeting with the hermit Paul which typifies his accession into the anchoritic Paradise, the so-called cave with the palm tree of the righteous and the well of salvation.

This same correspondence, as exemplified in the *vita Christi*, is presented in the other two ensembles of the altarpiece. The Passion of Christ is depicted first, for the reason that just as asceticism is the precondition for the hermits' beatitude, so too Christ's Passion and death on the Cross are the precondition for attaining the celestial Paradise. This is why John the Baptist—who in his way was the first of the anchorites and who is shown here with saints Anthony and Sebastian as witnesses—points to the suffering of Christ as the "increase" of God and to asceticism as the "decrease" of man. The presence of the Lamb makes even clearer the significance of Christ's suffering in bringing about Redemption.

The triptych of the middle position depicts the elevation of mankind to a state close to God, to a transfigured existence in the New Eden. The penetration of the divine nature into the human is illustrated on the left wing in the Angel Gabriel's annunciation to Mary. The full apparition of the divine nature within the human is consummated only in the Nativity itself, when the light of divinity is clad in the cloud of the human. The "humanization" of the divine is the pre-condition for its abasement in suffering. For this reason, on the predella in this position of the altarpiece we can still see the *Lamentation* which represents the lowest point touched by the divine way. Incarnation in human flesh, with the attendant abasement in suffering, has, however, as its end result the Transfiguration of the *natura humana*. This comes about in two ways: in the *Resurrection* on the right wing which is the return of the God-Man into the sphere of light of the Trinity, and in the Coronation of the Virgin as Queen of Heaven and of Angels in the central picture. The consequence of the clothing of the sun by the cloud is that, in Mary, human nature becomes clothed in the sun of Christ.

Beneath this very generalized theological content lies another and deeper stratum of meaning: the mystical participation of the contemplative soul in the *vita Christi* as the means of ascent toward God. The prototype of the contemplative soul is Mary herself, and the entire process of Redemption is, at the same time, a sequence of contemplative acts on the part of the Madonna.

The first act is *Compassio*, the ecstatic co-consummation of the Passion of Christ as the death of the sinfulness of human nature and as the increase of the godly nature. The *Compassio* is the recognition of that all-embracing character of the Passion which the artist portrays with all the immeasurableness of Christ's suffering.

In the triptych of the middle position, the *Annunciation*—the union of the divine with the human nature—takes place in the contemplation of the doctrine of the dual nature of Christ as set forth in Isaiah 7:14. Then, in contemplation of the Saviour made Man, of the Christ Child, Mary receives the revelation of Christ's triumph and His Redemption of mankind. And, along with the vision of His own glory, of His Transfiguration, the newborn Christ grants her also a vision of how the human form will undergo Transfiguration in and through her own Coronation.

The mystical apparition of Christ is consummated in the paradisiacal landscape of monastic life. At the foot of a high mountain is a monastery, seat of the *vita contemplativa*. As advocate of those who have chosen the monastic way, the

Madonna is surrounded by symbols of her virgin motherhood: the closed garden, the rose, the fig tree, the wine jug.

The vision of the Transfiguration of the human essence takes the form of the apparition of the Madonna as the blazing dawn and crowned by the Angel Gabriel with the crown of flames. In the new Jerusalem reborn on earth, symbol of her bridehood with Christ, she is clad as the new dawn in the sunlight of Christ. As such, she is raised above the nature of angels and receives their homage in the form of a mystical concert.

These two strata of the program, the generalized theological and the contemplative-mystic, are nevertheless no more than a background for the special concern which the preceptors of an Order, devoted to the care of the sick and responsible for a good part of all medical activity of the time, wished to have expressed on the main altar of their abbey church.

This other aspect involves the representation of a theology of corporeality, of the flesh in the Christian sense. The choice of the two particular episodes from the life of Anthony as well as the quite special assemblage and emphasis on precise aspects of the life of Christ both serve to make clear the twofold conception of corporeality in theological thought: on the one hand, the frailty of the human flesh which is subject to sickness, suffering, and death; on the other hand, the triumph of the flesh transfigured in the ultimate phase of salvation. As medieval theologians conceived it, Christ took upon Himself the frailty of human flesh as the sacrifice of the One for the All, and this was rendered by Grünewald in the superlative vehemence of the suffering and death of the crucified Christ which is itself expressive of the "increase" of God to which John the Baptist bears witness. But Christ took on mortal flesh in order to bring about the triumph of the flesh in His Resurrection and Ascension or, better, to make mankind behold in His person the promise of Transfiguration into incorporeal light.

As advocate for mankind and for the monastic life, Mary, through her motherhood, participates in Christ's taking on the flesh—the clothing of the sun by the cloud—and becomes therefore the first mortal to be granted the Transfiguration of the flesh and, in addition, receives the crown of Queen of Angels from Gabriel.

Transfigured corporeality is to be understood here as the transubstantiation of flesh into light, as propounded by the Neo-Platonic current in theology, a concept which constitutes a fundamental motif of Dante's *Divina Commedia*. This fact seems to have been the real reason why the patrons of this altarpiece reached back to the special conception of the Transfiguration and Coronation of the Virgin found in Dante. It must not be forgotten that, in such consistent emphasis on the transubstantiation of flesh into light, Grü-

newald constitutes a unique exception in medieval art, if one sets aside a few tentative starts in that direction on the part of Bosch. Certainly this was not a subjective concept championed by Grünewald on his own initiative. Rather it was a highly pregnant theme chosen deliberately by the sponsors of the altarpiece for its relationship to the character of their Order. Even so, Grünewald was the only artist ever to embody in images the Dantesque visions with such consistency and with a comparable degree of excellence.

This special point of view therefore constitutes the prism through which the episodes of the sacred legend as portrayed by Grünewald take on such an unusual character. One finds the theme of corporeality expressed in the traditional iconography of the Nativity and the Resurrection, but it is never brought exclusively into the foreground as in the Isenheim Altarpiece. Within the late-medieval naturalism of the time, this dual aspect inevitably came to realization as a special and highly exceptional contrast.

If the sick were in fact brought before the altarpiece as tradition says, or took part in the offices on the various feast days on which the altarpiece was opened and each of the ensembles shown, then they were presented with an optimistic interpretation of their physical ailments typical of the Middle Ages, since the promise of healing was extended not alone by the Order's patron saints but was there to be read in the life of Christ Himself.

In point of fact, the Isenheim Altarpiece is the most direct and to all intents and purposes the most significant artistic evidence of a special late-medieval concept of the body and of physical illness as emphasized by the Anthonite order, a concept which grew out of their own medical practice.

The devising of the program for this altarpiece was manifestly a special achievement on a high spiritual and theological level. It was in no sense merely a simple statement of the Order's tenets but, instead, reveals acquaintance with late-medieval mysticism and its literature and poetry. That themes found in Italian theology and poetry—that of Dante in particular—should play a role therein is not only not improbable but, in view of the Italian origins of the preceptors who commissioned the altarpiece, is to be expected. Whether, and to what extent, the artist himself was acquainted with the theological and literary sources is something we can scarcely decide. It is, however, certain that his very personal style was especially apt for the expression of such highly impressive subject matter.

What Grünewald realized in paint in the Isenheim Altarpiece was fully worthy of the profundity of the program set him. His personal achievement is in no way diminished when we understand the ideas that he illustrated. To the contrary, it is only thus that we can grasp the full range and grandiose power of his artistic imagination.

Notes

1 H. A. Schmid, *Die Gemälde und Zeichnungen von Matthias Grünewald*, 2 vols. (Strassburg, 1911).
W. K. Zülch, *Der historische Grünewald* (Munich, 1938).
W. Rolfs, *Die Grünewaldlegende* (Leipzig, 1923).
A. Burkhard, *Matthias Grünewald, Personality and Accomplishment* (Cambridge, Mass., 1936).
E. Ruhmer, *Matthias Grünewald* (Cologne, 1959).
A. M. Vogt, *Grünewald, Meister der gegenklassischen Malerei* (Stuttgart, 1957).
N. Pevsner and M. Meier, *Grünewald* (London, 1958).
Árpád Weixlgärtner, *Grünewald* (Vienna, 1962).
Maria Lanckorońska, *Matthäus Gotthart Neithart* (Darmstadt, 1963), includes an ample bibliography.
Pierre Schmitt, *Der Isenheimer Altar* (Stuttgart, 1967).

2 Aimar Falco, *Antonianae historiae compendium* (1835).
Pierre Hippolyte Helyot, *Geschichte aller geistlichen und weltlichen Klöster- und Ritterorden*, II (Leipzig, 1753), translation of *Histoire des ordres monastiques religieux et militaires, et des congrégations seculières de l'un et l'autre sexe . . .* (Paris, 1714–19).
M. Heimbucher, *Die Orden und Congregationen der katholischen Kirche* (2nd ed.; Paderborn, 1907), II.
V. Advielle, *Histoire de l'ordre hospitalier de Saint-Antoine-de-Viennois* (Paris, 1883).
J. Braun, *Tracht und Attribute der Heiligen in der deutschen Kunst* (Stuttgart, 1943).
L. M. von Hertling, *Antonius der Einsiedler* (Innsbruck, 1929).
P. Nordeloos, "La Translation de St.-Antoine en Dauphiné," *Analecta Bollandiana*, LX (1942), 68–81.
B. Lavaud, *Antoine le Grand, Père des moines* (Fribourg, 1943).
S. Bouyer, *La vie de St.-Antoine* (Paris, 1943).

3 Thalhofer, ed., *Bibliothek der Kirchenväter: Schriften des Hl. Athanasius*, II, trans. P. Richard, introductory notes, p. 220, "Vita B. Antonii."
Ausgewählte Schriften des Hl. Hieronymus, II, trans. P. Leipelt, "Vita B. Pauli." The *Vita Pauli* is available in English in Helen Waddell, *Vitae Patrum: The Desert Fathers* (original edition London, 1936; reprinted Ann Arbor, Mich., 1957), p. 26.
The two works are hereinafter cited as *Vita B. Antonii* and *Vita B. Pauli*.

4 Major examples: Santa Maria Antiqua, Rome, tenth century, and in the atrium of Sant'Angelo in Formis, Capua, twelfth century.

5 Concerning the healing of the sick: *Vita B. Antonii*, chaps. 56–59; Anthony as judge: chaps. 84–85; the prediction of a great punishment and its fulfillment: chap. 86.
H. Chaumartin, *Le Feu de St.-Antoine* (Vienna, 1946).
W. Kühn, "Gestalt und antike Vorbilder des Antonius Eremita," *Psyche*, II (1948), 71–96.

6 P. Toschi, *La poesia popolare religiosa in Italia* (Florence, 1935), pp. 107–12.
A. van Genepp, "Le Culte populaire de St.-Antoine Ermite en Savoie," *Actes et Mémoires du Congrès d'histoire de la religion*, II (1923), 132–68.
F. Novati, "Sopra un'antica storia lombarda di Sant'Antonio di Vienna," *Miscellanea d'Antonio* (Florence, 1901).
F. d'Elia, *Il falò di Sant'Antonio* (Florence, 1912).

7 J. Baum, *Martin Schongauer* (Vienna, 1948), pls. 186–88.

8 H. A. Schmid, *Die Gemälde . . .*, pp. 67 ff. In his "Quellen," nos. 32 and 44, respectively, there are documents mentioning Guersi's building activities, one in the *Gebweiler Chronik* of about 1540 and the other in a list of preceptors compiled around the end of the seventeenth century.

9 Zülch, *Der historische Grünewald*, p. 134.

10 Schmid, *Die Gemälde . . .*, pp. 116 ff.; Baum, *Martin Schongauer*, pp. 51 ff., pl. 151.

11 W. Vöge, *Niclas Hagnower, der Meister des Isenheimer Hochaltars und seine Frühwerke* (Freiburg im Breisgau, 1931), which includes photographs of the altarpiece by Hans Sixt von Staufen in the Locherer chapel of the minster at Freiburg im Breisgau; as against Vöge, cf. Thieme-Becker, *Künstlerlexikon*, VI.
It is very unlikely that the statues in the shrine are the work of Grünewald himself as has recently once again been proposed. The arguments put forward by Maria Lanckorońska, *Matthäus Neithart Sculptor* (Munich, 1965), simply do not hold water.

12 Vöge, *Niclas Hagnower . . .*, pp. 14 ff.

13 W. Fraenger, *Matthias Grünewald in seinen Werken: Ein physiognomischer Versuch* (Berlin, 1936).

14 Baum, *Martin Schongauer*, fig. 151.

15 H. F. Schmidt, "Voraussetzungen der Kunst Grünewalds," *Zeitschrift des Deutschen Vereins für Kunstwissenschaft*, VII (1940), 89–103.

16 Schmid, *Die Gemälde . . .*, p. 116.
H. Feurstein, *Matthias Grünewald* (Bonn, 1930).

17 O. Schürer, "Über Landschaftsdarstellung in der deutschen Kunst um 1500," *Festschrift Richard Hamann* (Burg bei Magdeburg, 1939).

18 H. Bouchot, *Les Primitifs français* (Paris, 1904). The altarpiece was installed in 1399.
H. von Einem, "Die 'Menschwerdung Christi' des Isenheimer Altares," *Kunstgeschichtliche Studien für Hans Kauffmann* (Berlin, 1956).

19 M. L. Schmidt, "Der Lettner im Breisacher Münster," *Oberrheinische Kunst*, III (1928), 87–93, fig. 2.

20 Schmidt, "Voraussetzungen . . .," pp. 89 ff.

21 Rolfs, *Die Grünewaldlegende*, p. 14.

22 H. Schrade, *Die Auferstehung Christi. Ikonographie der christlichen Kunst*, I (Berlin-Leipzig, 1932).

23 L. Planiscig, *Luca della Robbia* (Vienna, 1940).

24 Direct influence from Leonardo can be made out clearly in the style of drawing, in the accurate observation of aerial perspective, and in a conception of the human figure which tends toward caricature. In its painterly application of color, the treatment of drapery has relationships with Titian's early Madonnas. The hypotheses of Maria Lanckorońska, *Neithart in Italien* (Munich, 1967), concerning Grünewald's contact with Italian art are, however, for the most part erroneous.

25 Vogt, *Grünewald,* . . .

26 Schmid, *Die Gemälde* . . . , pp. 116 ff.

27 Braun, *Tracht und Attribute der Heiligen* . . . , p. 93, fig. 39.

28 *Vita B. Antonii*, chap. 51.

29 *Vita B. Antonii*, chap. 59, tells of his vengeance on Ballachius.

30 *Ibid.*, chap. 29.

31 Mentioned by Ibn Ezra. The association Saturn-melancholia-anchorite is thoroughly explored in E. Panofsky and F. Saxl, *Dürer's Kupferstich "Melencolia I"; Eine quellen- und typengeschichtliche Untersuchung* (Leipzig-Berlin, 1923).

A. Chastel, "La Tentation de Saint-Antoine ou le songe du mélancolique," *Gazette des Beaux-Arts*, XV (1936).

R. Corso, "Il porco di Sant'Antonio," *Il Folklore italiano*, I (1925), 316–17.

Kühn, "Gestalt und antike Vorbilder . . . ," p. 85, shows a page from ms. M. d. 2 at the University Library, Tübingen with "Saturn im Gestalt eines Antoniters."

32 Max Geisberg, *Der Meister E.S.* ("Meister der Graphik" series, vol. X), (Leipzig, 1924), pl. 49.

33 Lavaud, *Antoine le Grand* . . . , pp. 12 ff.

34 Cf. also Baum, *Martin Schongauer*, p. 37.

35 W. Rolfs, "Die Vorlage für Grünewalds Versuchung des Hl. Anton vom Isenheimer Altar," *Repertorium für Kunstwissenschaft*, XLII (1920), 238.

Weixlgärtner, *Grünewald*, p. 25.

O. Benesch, *Die altdeutsche Malerei* (Basel, 1967).

36 *Vita B. Antonii*, chap. 65. There is an unsuccessful attempt to identify Grünewald's demons as Deadly Sins in Feurstein, *Matthias Grünewald*, p. 62.

37 *Vita B. Antonii*, chap. 8.

On a slip of paper in the right lower corner of the picture is written an exclamation of Saint Anthony: "Ubi eras Ihesu bone, ubi eras. Quare non affuisti ut sanares vulnera mea," whose text differs in some particulars from the Latin of the *Vita B. Antonii* and is apparently a formula of prayer.

Zülch, *Der historische Grünewald*, p. 214.

38 *Vita B. Antonii*, chap. 7.

39 *Ibid.*, chap. 36.

40 C. de Tolnay, *Hieronymus Bosch* (Basel, 1937), fig. 49. For the liturgy of the witches' Sabbath with its imitation of sacred actions and its incendiarism, cf. pp. 28 ff.

41 *Vita B. Antonii*, chap. 38.

42 E. Holländer, *Die Medizin in der klassischen Malerei* (Stuttgart, 1913). E. Wickersheimer, "Matthias Grünewald et le feu d'Antoine," *Premier congrès de l'histoire de l'art de guérir, Antwerp, 1920: Liber memorialis* (Antwerp, 1921).

43 Concerning the healing mantle, see *Vita B. Pauli*, chap. 12. There is an example of the miraculous powers of a mantle in the life of Saint Egidius (Giles) as told in the *Legenda Aurea* (the *Golden Legend*) I, trans. Benz, 1926, p. 111: "On his way to church one day he saw a sick man lying in the square and begging for alms. He gave him his cloak, the poor man put it on, and immediately was cured."

44 Despite the coat of arms, it is far from certain that this is a portrait of Guersi, and the same is true of that supposed to be of Grünewald himself. It has been proposed that other figures in the altarpiece are self-portraits, among them Saint Sebastian and John the Baptist, the latter because he has been said to hold an alleged attribute—a paint brush—in the hand that points to Christ. This "brush" is however only the ball of his thumb (cf. Lanckorońska, *Matthäus Gotthart Neithart*). In any case, it is time to drop the entire problematical matter of Grünewald's alleged self-portraits, and we do not intend to go into it here.

45 The widespread assumption that Grünewald portrayed himself in the Paul is, on this basis, unlikely.

46 Basilius, *Opera omnia*, in Migne, *Patrol. Graec.*, 29–31, 32, 276, trans. Borinski, Lit. 104, I, pp. 18 ff. speaks of the desert as symbolic landscape.

Basilius, *Epistle 42 to Chilo*, in Migne, *Patrol. Graec.*, 29, trans. Karrer, Lit. 21, pp. 112 ff. "I confess, I tarry in this desert, thou evil thought—in the desert in which our Lord too tarried! Here is the oak tree, here the ladder to Heaven, the troops of angels that Jacob beheld. Here is the desert where the purified folk received the Law and could behold God in their pilgrimage to the Land of Promise. Here is Mount Carmel on which Elijah tarried and was pleasing to God. Here is the plain where Esdras went, at God's command, to study in the holy books. Here is the desert in which Saint John ate locusts and called on men to repent. Here is the Mount of Olives that Christ climbed in order to pray and to teach us to pray. Here is Christ himself, the Friend of Solitude. Because he declares, 'For where two or three are gathered together in my name, there am I in the midst of them.' Here is the strait and narrow path that leads to life. Here are the teachers and prophets who roamed about in deserts and mountains, in caves and clefts in the earth. Here are the Apostles and Evangelists and the life of the monks who reject the world. This it is that I have taken up of my free will, to attain what is promised to those who testify by their blood to Christ and to all the other saints. . . . And, finally, there am I not for the world but, rather, the world is for me!"

It is unquestionable that what is meant here is a specific type of symbolic landscape with mountain, forest, plain, and everything else that goes to make up the "anchoritic landscape." Conceived of as "desert," it was sought by all the hermits as the New Eden where they would meet with Christ. We can adduce also the description of Anthony's hermitage in the *Vita Hilarion*, chap. 31 (cited after the German translation by P. Leipelt, *Bibliothek der Kirchenväter* series, ed. Thalhofer, 1874): "Since the occasion offers itself here, and since we have come so far in our tale, it would seem to be only proper to describe however briefly the dwelling place of such a great man. It was a tall mountain of rock of something like a thousand paces in length, at whose foot springs of water trickled out, of which some were swallowed up by the sands while others poured down into the valley to make a brook. On the banks grew palms, which conferred on the place a great charm of amenity but also at the same time offered considerable advantages." This is the same type of landscape described in the *Vita B. Pauli*.

For the connection between *humilitas* and the choice of life in the blossoming desert, we can quote Saint Ambrose, *On Virginity*, chap. 9 (cited after the German translation by Schulte in the *Bibliothek der Kirchenväter* series, ed. Thalhofer, 1871, p. 166):

"So seek we then Christ there where the Church seeks Him, on those heights around whose peaks hovers the sweet scent of the noblest good works. He shuns the public highways, He holds Himself aloof from the noisy crowds in the marketplace in accord with the words, 'Make haste, my beloved, and be thou like to a roe or

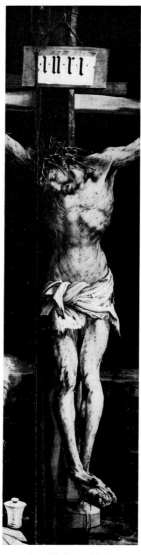

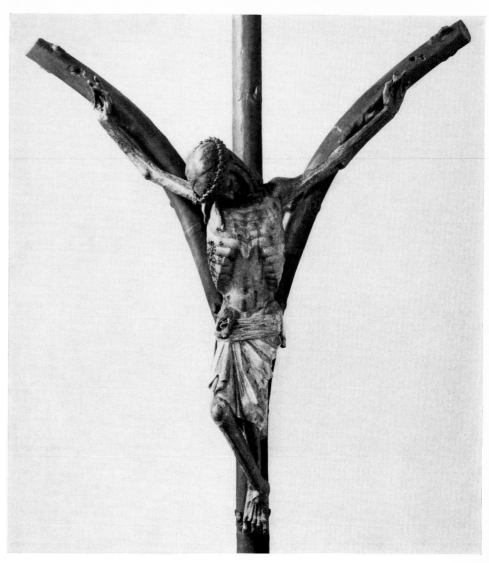

21 Crucifixion: Christ

22 Plague crucifix. Saint Maria im Kapitol, Cologne

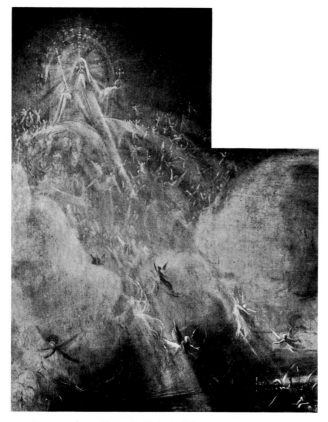

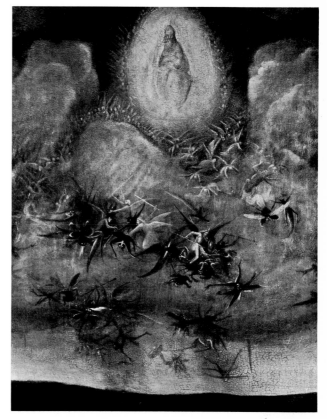

23 Incarnation: The celestial gloriole

24 Hieronymus Bosch. Last Judgment (detail). Academy, Vienna

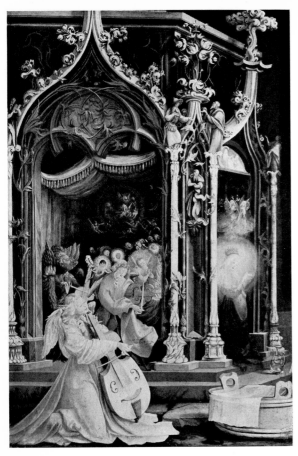

25 The Angelic Concert: The baldachin

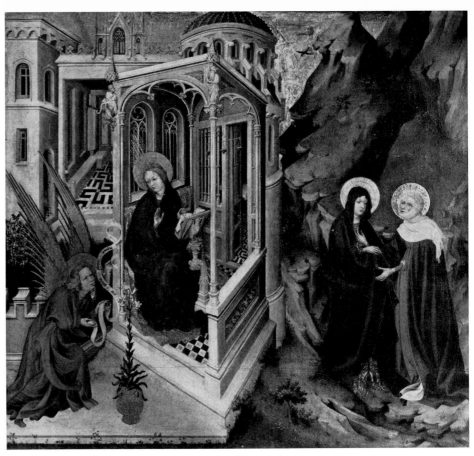

26 Melchior Broederlam. Annunciation and Visitation (detail). Musée de la Ville, Dijon

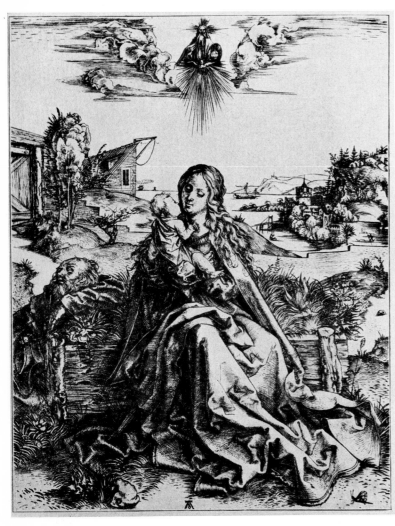

27 Albrecht Dürer. Virgin with the Dragonfly. Engraving

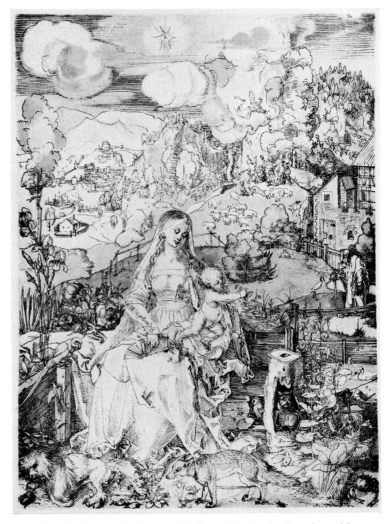

28 Albrecht Dürer. Madonna with Several Animals. Drawing with watercolor

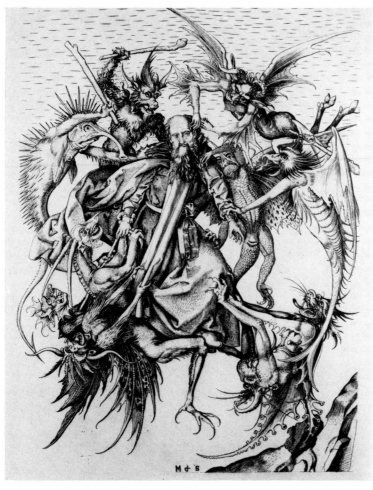

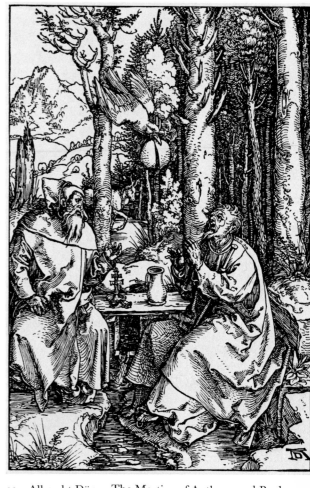

29 Martin Schongauer. The Temptation of Saint Anthony. Engraving

30 Albrecht Dürer. The Meeting of Anthony and Paul. Woodcut

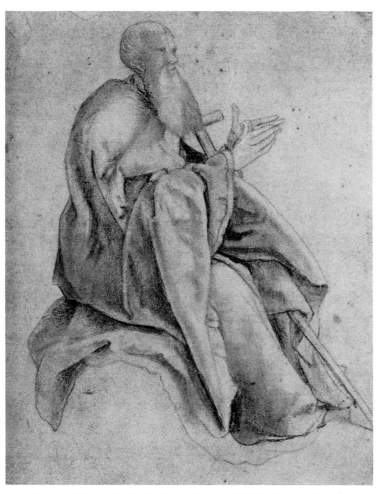

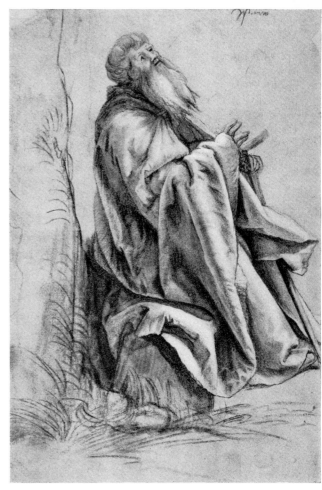

31 Grünewald. Study for Anthony. Formerly Print Room, Dresden

32 Grünewald. Study for Anthony. Formerly Print Room, East Berlin

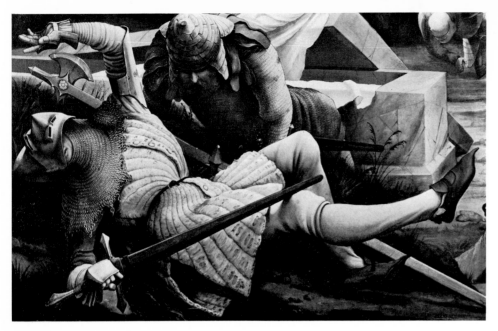

33 Resurrection: The Watchers

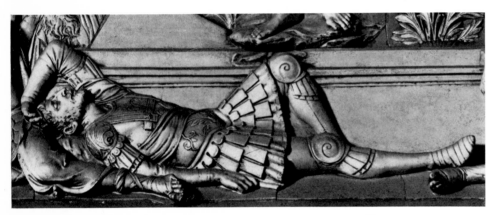

34 Luca della Robbia. Resurrection relief (detail of watcher). Duomo, Florence

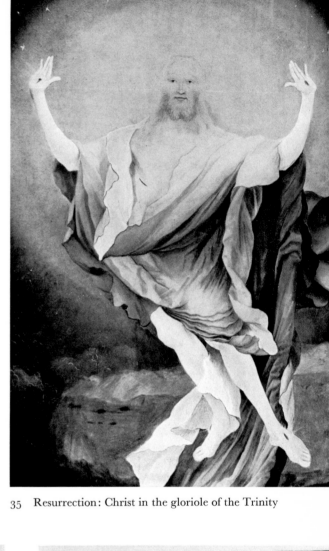

35 Resurrection: Christ in the gloriole of the Trinity

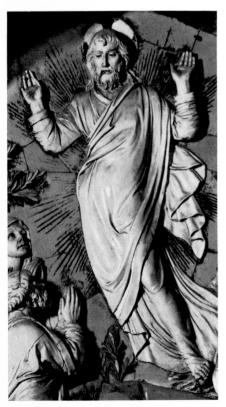

36 Luca della Robbia. Ascension relief (detail). Duomo, Florence

37 Raphael. Resurrection. Drawing. Musée Bonnat, Bayonne

38 Trinity. Miniature from Hildegarde of Bingen, *Scivias*. University Library, Heidelberg

to a young hart upon the mountains of spices.' Those therefore have truly climbed the peaks of Faith in the mettlesome ways of Virtue who believe that Christ died and was buried, who in spirit have accompanied His holy body to its mountain tomb and anointed it with spices; they know too that the Lord has arisen in glory. . . ."

The Lord Himself, says Ambrose, tells us where He is to be found: "I am a flower in the fields and a lily of the valleys, as the lily among thorns. . . ." He continues: "That is the desert, my daughters, which leads to the realm of Heaven; it is also that desert which, adorned with the blossoms of lilies, shines according to the words of the Prophet: 'The wilderness and the solitary place shall be glad for them; and the desert shall rejoice and blossom as the rose.'

"In this desert rises the good tree which bears good fruits; it begins by stretching out its branches all around, but its topmost branches reach up to Heaven, to the knees of the Divinity. Would that the tree of our life likewise would be touched by a fructifying ray of divinity, so that the words could be said of it, 'As the apple tree among the trees of the wood, so is my beloved among the sons.'"

In chapter 10 Ambrose says: "So therefore you know now where Christ is to be sought. . . . Call on the Holy Spirit with those words from the Song of Solomon: 'Awake, O north wind; and come thou, south; blow upon my garden. . . .' The garden of the eternal Word is the soul ever blooming in pious thoughts. . . ."

Concerning the blossoming desert and its significance as a mystical metaphor, see also Engelberger, *Prediger, Predigten und Gebete* (Basel, 1876): "Indeed, the higher one ascends in the desert, the sweeter are the ways one finds, the brighter sing the birds, the more savory are the herbs, the more beautiful to the eye the flowers. It is because the Heavenly Father stretches before men the flowering verdure of His only begotten Son so that they will follow Him into the desert, indeed from the human state to the divine, from the Son to the Father, from image and form to the unimaginable." There too, according to W. Muschg, *Die Mystik in der Schweiz, 1200–1500* (Leipzig, 1935), p. 322, "the sight of the Alps as they are in summer gleams clearly," which is a translation of a symbolic concept into a specific, known landscape, exactly as appears to be the case in Grünewald's painting.

There is no lack of relevant passages in the literature. The blossoming desert is familiar also in the iconography of the visual arts, as, for example, in the engraving in Dresden by the Baptista Master (reproduced in Geisberg, *Der Meister E.S.*) where the brook, flowers, birds, and trees with fruit are especially conspicuous. For his woodcut of *The Meeting of Anthony and Paul* (B. 107) (our fig. 30), Dürer transposes the scene into a wooded valley with a view of a distant mountain. All things considered, the fact that Grünewald constructed his landscapes in symbolic terms is so evident that it can only have been deliberate.

47 Such an interpretation of the cave of Saint Anthony is in no way contradicted by the fact that in a few German passionals (cf. Severin Rüttgers, *Der Heiligen Leben und Leiden*, winter section, p. 266) the two legends are combined and the story of Paul, including the encounter in the cave, precedes the story of Anthony and, accordingly, of his temptation, since this is no more than an arbitrary juxtaposition of the two legends.

48 Cf. also Friedrich Winkler, *Die Zeichnungen Albrecht Dürers*, vol. II (Berlin, 1936–39).

49 In the *Legenda Aurea* (cited after the edition and translation by Benz, I, p. 111) we read: "There he found a cave with a spring. And God sent him a hind which came every day at a set hour and nourished him with her milk. . . . There they saw a venerable graybeard seated in monk's costume with the hind crouching at his feet."

Grünewald's embellishment of the composition with both a stag and a hind is therefore within the context of the general concept of symbolic animals associated with hermits.

50 L. Behling, *Die Pflanze in der mittelalterlichen Tafelmalerei* (Weimar, 1957), pp. 140 ff.
W. Kühn, "Grünewalds Isenheimer Altar als Darstellung mittelalterlicher Heilkräuter," *Kosmos* (1948), pp. 327 ff.

51 For the liturgy of the Golden Mass, cf. S. Beissel, *Geschichte der Verehrung Marias in Deutschland während des Mittelalters* (Freiburg, 1909), and J. Walter, "Über die Einwirkung der Strassburger Liturgie auf Grünewalds Verkündigung," *Jahrbuch der Elsass-Lothringischen Wissenschaftlichen Gesellschaft zu Strassburg*, VI (1933).

52 J. Bernhart, *Die Symbolik im Menschwerdungsbild des Isenheimer Altars* (Munich, 1921).

53 For the conception as an act of contemplation, cf. Albertus Magnus, *Opera*, XXXVII (Paris, 1898), Mariale, 1 ff., and especially Ludolph von Sachsen, *Vita Christi*, ed. S. Wosinski (1715), chap. 5: "Credendum autem, quod maria tunc erat tota abstracta in devotissima oratione vel intimata contemplatione, consurgente forte tunc specialiter ex meditatione super salute generis humani, qualiter scilicet per virginem deberet salvari. Unde etiam quidam dicunt, eam tunc actu legisse illut isaiae: 'ecce virgo concipiet. . . .'"

54 Schrade, *Die Auferstehung Christi*.

55 *Ibid.*, p. 86.

56 *Ibid.*, fig. 115.

57 Johannes von Castel, "De adherendo deo," as published by Grabmann in the *Tübinger Quartalschrift* (1920), pp. 186 ff.: "Laternae vulnerum Christi" as the *lumen increatum* shining through the human form of Christ. For this reason, in mystic contemplation the wounds of Christ are perceived as glowing with light, as in the case of Ita von Huttwil who "saw from the five wounds of Christ a light burst forth glowing with more radiant power than the sun" (Muschg, *Die Mystik . . .*, p. 116).

58 A basic source for the ontic theory of light of the Middle Ages is Clemens Bäumker, *Vitelo, ein Philosoph und Naturforscher des 13. Jahrhunderts* (Münster, 1908), which also has a thorough exposition of the Trinity in its form as three concentric circles of light.

59 Cf. H. Liebeschütz, "Das allegorische Weltbild der hl. Hildegard von Bingen," *Kulturwissenschaftliche Bibliothek Warburg*, XVI (1930). Reproduction in H. Fegers, "Die Bilder im 'Scivias' der Hildegard von Bingen," *Das Werk des Künstlers* (1939), 109–45.

60 J. Bernhart, *Die philosophische Mystik des Mittelalters* (Munich, 1922), fig. 1.

61 R. Durrer, *Bruder Klaus*, 2 vols. (Sarnen, 1917–21). Here we have the great vision of Nicholas of Flüe: "It is told that all who visited him were taken with fright at their first glimpse of him. Nicholas explained this, saying that once in the dark night sky he had seen a human countenance surrounded by a tremendous light, before which he fell to the ground."
For the magical circle as an age-old contemplative symbol, the mandala (mandorla), cf. C. G. Jung, *Das Geheimnis der goldenen Blüte* (Leipzig, 1939), p. 23. In English, as "Commentary on 'The Secret of the Golden Flower,'" in Jung, *Alchemical Studies* (Princeton, 1967).

62 Dante, *Paradiso*, Canto XXXIII. This and all subsequent citations of Dante are from the translation by Dorothy L. Sayers and Barbara Reynolds, 2nd ed. (Baltimore, 1964).

63 I do not choose to concern myself here with the aberrant theories that see in the small figure beneath the baldachin not Mary but, instead, some saint or even the Queen of Sheba. For these, see:
E. Poeschel, "Zur Deutung von Grünewalds Weihnachtsbild," *Zeitschrift für Kunstgeschichte*, XIII (1950), 92 ff., and

G. Münzel, "Eine neue Erklärung zu dem Menschwerdungsbilde im Isenheimer Altar," *Zeitschrift für Kunstgeschichte*, XV (1952), 75 ff. The point of view of Poeschel is wholly untenable for even more reasons than those already adduced in refutation by Münzel. It is not possible for the Queen of Sheba to be designated by the same kind of aureole as that surrounding the risen Christ.

Similarly, other interpretations of the central picture which are based on no more than mere speculative theorizing are mentioned only where, in certain particulars, they may be worthy of consideration. Among these is:

W. Rügamer, "Der Isenheimer Altar Matthias Grünewalds im Lichte der Liturgie und der kirchlichen Reformbewegung," *Theologische Quartalschrift*, 121 (1940), 86 ff.

Also see Lanckorońska, *Matthäus Gotthart Neithart* for further bibliography.

64 H. Kögler, "Zu Grünewalds Isenheimer Altar," *Repertorium für Kunstwissenschaft*, XXX (1907), 314.
K. Lange, "'Mariä Erwartung,' ein Bild Grünewalds," *Repertorium für Kunstwissenschaft*, XXXIII (1910), 120.
Lange himself has to admit, however, that while awaiting the birth, Mary no longer lived in the Temple but, instead, in the house of Joseph, so this juxtaposition of images cannot be taken to be a historical scene.

65 Bernhart, *Die Symbolik im Menschwerdungsbild.* . . .

66 Bernhart believed he had found proof for this hypothesis in the repetition of the text Mary reads in the *Annunciation*, since this would make of it a liturgical formula. However, there it is only an allusion to the Mother of God's spiritual contemplation during prayer.

67 Most quixotic of all is his attempt to explain the group in the background beneath the baldachin, among whom there is a large angel covered with feathers gazing up at a dark blue aureole which contains small winged figures hovering aloft. Completely without any iconographical basis he identifies one of the figures as Eve and another, the one with double wings and a diadem from which light streams out to the rear, as the sibyl who prophesied the birth of the Messiah to the Jews. What is more, the feathered angel looking up at the aureole is, according to Bernhart, the legendary bird Charadrius or Calonder which looks aloft to Eve, the "mater naturae," to "announce to her and to all victims of the Fall through Sin that there is henceforth the certainty of redemption through grace." Bernhart's idea about the group of angels under the baldachin has often been challenged. In any case, the angel he wishes to identify as the bird Charadrius is a highly imaginative recasting of a type of feathered angel familiar mainly in German sculpture but also in painting. If one wishes to consider the haloed and winged figures with "exotic" facial features as personifications of the *gentes*, this would point to an interpretation of the small Madonna and the small Temple as *Ecclesia*, but certainly not to the symbolic representation of an Old Testament world-advent.

68 L. Burger, *Die Himmelskönigin der Apokalypse in der Kunst des Mittelalters* (Berlin, 1937).

69 The cornerstone is certainly not easy to find. He conjectures that it is a piece of the base to the left of the Madonna.

70 R. Weser, *Der Isenheimer Altar* (Ulm, 1926).
The landscape and surroundings of the large Madonna with the Child do not in any way coalesce into a picture of purely Marian symbolism. This has led to attempts to interpret the Marian symbols as being relevant to Christ also. Thus, for example, the *hortus conclusus* would be the wall between Heaven and earth that Christ broke down, or the rose would be the rose of Christ's Passion also. This approach, favored by Weser in particular, does not however hold water. The closed garden and the rose in juxtaposition can only be understood as a perfectly clear iconographical allusion to Mary. In fact, it happens to be the only one in the entire picture about which, even at first glance, one need have no question. The dispute over whether the picture refers more to Mary or to Christ proves only that a consistent theological interpretation cannot be achieved merely by adding more and more symbolic relationships.

71 The scene of the annunciation to the shepherds is truly a foreign body within this symbolic landscape, and its angels in particular are most strange. Since one of the angels has a beard and appears to wear a belted garment, "they can only be citizens of the realm of the Blessed." Consequently there remains to Bernhart "in accord with Catholic dogma, only the possibility of thinking of Enoch and Elijah who were taken up into Heaven." However, those prophets are invariably considered in the literature to be forerunners of the Last Judgment, and their appearance in an annunciation to the shepherds is completely unheard of and would require some special explanation.

72 Kögler, "Zu Grünewalds Isenheimer Altar."

73 F. Schneider, "Matthias Grünewald und die Mystik," (Kunstwissenschaftliche Studien) *Gesammelte Aufsätze*, I (1913).
R. Günther, "Die Brautmystik im Mittelbild des Isenheimer Altars," *Studien über christliche Denkmäler*, ed. J. Ficker (Leipzig, 1924).

74 Feurstein, *Matthias Grünewald.*
W. Niemeyer, *Matthias Grünewald* (Berlin, 1921).
Feurstein was the first to believe that a single literary source could be found for the entire middle panel, the *sermo angelicus* of Saint Bridget of Sweden. That small book, printed in Grünewald's time and quite certainly widely distributed, contains a series of meditations on the role of the Madonna in the history of the Redemption. The meditations are set down according to the days of the week and arranged in readings. Feurstein has published a selection from these which he proposes as the text underlying this picture.

The meditations follow a set plan. From Sunday through Tuesday they treat of the divine providence of the Madonna, the jubilation of the angels over God's decision to create Mary, the perpetuation of these prophetic tidings from Abraham to Isaac and thence to the patriarchs and prophets who rejoiced to know that "the temple of the blessed womb of Mary would yet be created." On Wednesday and during the first readings for Thursday, the meditations concern the creation of Mary and her childhood and compare the "blessed body of the child Mary" to a "vessel of purest crystal," her soul to a "lantern from which light streams forth," her love to a "glowing flame." The remaining readings for Thursday and those for Friday speak of the exceptional spiritual fitness of Mary for her role as bearer of God. They state that from the first moment of the Incarnation, that is, from the Annunciation on, she was enlightened with full foreknowledge of the mystery of the Redemption, the Passion, and the Resurrection. She is likened to a rose among thorns because she was at one and the same time "the most joyful and the most sorrowful of all mothers." In all the happy events of her life, the Conception, the Nativity, and thereafter "each time she wrapped the Child in His swaddling clothes or gazed on her newborn Son," she experienced a premonition of the suffering to come. In her grief at the Crucifixion she preserved her faith in the glorious Resurrection to come, and she was thereby the one true witness to the certainty that Christ would rise.

Feurstein presumes that this text determined the choice of subjects and the manner of their presentation in both of the first two positions of the altarpiece. Those two ensembles would therefore be based on a Marian idea. As Feurstein sees it, the key and "virtually geometrical central point" of the interpretation is the

"mysterious figure" beneath the baldachin. She is the *Maria aeterna*, "Mary as Idea." The entire mystery of salvation is presented in these pictures as "the ideal and real progress of Mary through all the millennia of the history of salvation." The scene under the baldachin is "her election in the bosom of the Father, her salutation by the angels on the morning of the Creation ... the joyous expectation of her on the part of the ancestors, patriarchs and prophets, her significance as Second Temple and most worthy portal." The Annunciation is "her preparation by the angelic tidings for the work of Redemption." The Madonna in the landscape reveals her "double fate as the heavily thorned Rose of Jericho, that is, as the most joyful and most sorrowful of all mothers." The Crucifixion and Entombment are "the Good Friday hours of her life," and the Resurrection alludes to "her highest day of honor as witness to the rising of Christ."

In itself, however, Feurstein's interpretation is improbable. In order to follow the sequence of the meditations, he is forced to do violence to the entire composition of the altarpiece. There is no "intellectual basis" on which to connect the Mary who existed before time with the birth of Christ, to make the Crucifixion precede the Nativity, and to annex the Resurrection to the latter event which, nevertheless, is not spoken of in the text until after the death of Christ and even appears there as a consequence of the Passion. For the juxtaposition of two Madonnas in the central picture, Feurstein has no choice except to do more or less as Niemeyer did and adduce only the most generalized definitions. Thus, on the left we would have "Mary as Idea, as eternal thought, germinating, growing. Mary before time was, on the threshold of time, beholding herself as the fulfillment of time." On the right we have "Mary as creature, as woman, as the vehicle for the accomplishment of God's destiny on earth." Yet nothing in Saint Bridget's text even suggests a pictorial juxtaposition of a Madonna-before-time with a Madonna-within-time. Moreover, this simply leaves out of consideration the entire pictorial conception of the right half of the picture, the Madonna in the landscape. In plain fact, the *sermo angelicus* simply does not furnish any kind of theological intellectual armature which can explain the very special composition of this central picture, let alone the juxtaposition of the three pictures which make up this ensemble. In short, Bridget's meditations do no more than follow the familiar conception of the process of salvation.

Nevertheless, her text is fascinating in a quite different connection. Bridget's mystical language is replete with the most diversified poetic comparisons, and it has been suggested that this was the direct inspiration for Grünewald's "visionary" style. The numerous similes involving light have been thought to be the basis for Grünewald's representations of transfiguration through light. However, in the particular passages that Feurstein relates to the picture there are two entirely different aspects susceptible of exerting an influence on the artist. For the most part there are metaphors of theological content, some purely subjective, others drawn from the common repertory of symbols. But there are also pure descriptions, of the Madonna, for instance, or of the crucified Christ, and Grünewald is said to have translated these into paint with such fidelity that they seem to be descriptions of his images. Both types give rise to crucial questions concerning the relationship between a literary source and a pictorial representation. Here we shall examine chiefly the metaphors.

For the still-uncreated "Madonna of the divine decree" that Feurstein sees in the figure beneath the baldachin, the text suggests certain comparisons. In accord with the general context of Proverbs 8:22–36, the pre-existent eternal wisdom is understood to be the Madonna of divine providence as "microcosm." This "small world" is conceived by Bridget in analogy to the macrocosm. It ha a "sun, which is divine obedience, and a moon which is steadfast faith, while the stars in the heavens are the loving thoughts of the heart." Behind this idea there is obviously a cosmological allegory of the kind so frequent in mystical theology. But because Bridget refers to the sun and the moon as two lights, Feurstein believes that they are represented in the double luminous nimbus of the small Madonna. The fact is, there is really no basis whatsoever for relating this text to Grünewald's picture. For the fiery crown worn by the Madonna, Feurstein adduces a passage which defines Mary as the "crown of honor of God ... adorning God Himself." But it is clear therefore that Bridget thinks of this crown as being on the head of God, not on Mary's. Further, the text has a number of similes concerning the "blessed womb of Mary," that is, of the already created Madonna. The womb is compared with a temple, hailed as "the most worthy portal," said to be "like a vessel of purest crystal," and her soul is "a radiant light, her mind a fountain whose jets of water soar high and then plunge down into a deep abyss." In the fire of love she is like "a glowing flame." For all that these comparisons are of the most generalized character, Feurstein connects them all with the Madonna beneath the baldachin, although they no longer pertain to the Madonna from before time but rather to the Mary created within time. The "temple" or "most worthy portal" is, for Feurstein, the baldachin on which, he stresses, appear the patriarchs and prophets who await the Madonna. On the steps stands "the vessel of purest crystal." The angels, who in Bridget's text rejoice when they learn of the divine decree to create Mary, make music here in the symbolic temple (once likened to the body or womb of Mary, another time treated as a kind of symbol of the Old Testament) on the morning of the creation, and they are joined by the first pair of human beings and all the other beings who await the creation of Mary—who at the same time is shown as already created and, indeed, already pregnant.

It is perfectly clear from this that the scene on the left half of the picture cannot be clarified by the ideas and symbolic comparisons of the text by Saint Bridget. For the uncreated Madonna of divine providence—the central idea of the left half of the picture according to Feurstein—it offers no more than a cosmological allegory which defies depiction. All the other metaphors, insofar as they represent anything lending itself to depiction, relate only to the created Madonna, the large figure on the right side. If one insists on finding in the left half of the picture some sort of unified idea derived from the general thought of Bridget, then it is only that once again hidden therein is the old notion of a world-advent.

75 Zülch, *Der historische Grünewald*.

In his comprehensive study on Grünewald, Zülch was cognizant of the arguments advanced in the previous note. Accepting that there might have been some influence from the writings of Saint Bridget, he nevertheless returned to the scheme proposed by Bernhart and, in consequence, bundled together both or, to tell the truth, all interpretations. By drawing on all of Bridget's writings and not just the *sermo angelicus*, he tried to establish some broader basis for an explanation. The upshot is that alongside the old metaphors many new ones are dragged in, even though they are quite outside the context—something Feurstein at least respected.

The baldachin is not only the Temple of Solomon in which Mary is "prefigured" but also a "house in which you [Mary] should dwell, namely, the Almighty God Himself"—meaning, says Zülch, that the Temple is "God and Mary at one and the same time, and in her glows God's light." The figure beneath the baldachin is defined in connection with the *sermo angelicus* primarily as the Mary of divine decree. But since most of the metaphors pertain to the Mary of the

time before the Incarnation, she is at the same time taken to be the created Mary who awaits the birth. For her Transfiguration, Zülch brings in an absolute fireworks of metaphors for light. First we have the vision of the "crowned Queen of Heaven," a "virgin glowing in the miraculous glow and having on her head a priceless crown." Which, in the final analysis, would make the small figure also the Madonna who died and was taken up into Heaven. Then we are given the "burning thornbush," the "flame of divine love," and the frequently encountered comparison of Mary with the dawn. The fact is, only the latter metaphor contains a concept which can be related to the transfigured Virgin. "Mary is the dawn illuminated by the sun of Christ within her" (Bridget 4:11). In any case, here one may well assume that the nimbus of sun with the red border that Grünewald painted illustrates this mystical metaphor. However, Zülch makes no effort to connect on theological grounds this many-sided metaphor with the quite similar sun-glory around the risen Christ. Whereas there the nimbus is perfectly clear in iconographic terms, signifying the entry of the transfigured flesh into the existence of God in the form of light, the *Madonna aeterna* remains a wholly imaginary figure vacillating somewhere between a transcendental, a real, and a poetic existence. "There can be no doubt that here, created out of the vast body of Marian poetry, we have kneeling before us the *Maria aeterna*, the bearer of God who was created by divine decree before the creation of the world and who is shown in the state of expectation and as foremost among all those who wait."

This imprecise definition by Zülch shows clearly how little Bridget's text actually contributes to the theological interpretation of the problematic figure. True, it introduces a new idea, that of the Madonna of divine providence who existed before time. But that idea contains nothing that even remotely can be said to provide the artist with a recognizable inspiration for a Madonna in a nimbus of Transfiguration, nor in Bridget's writings is this timeless Madonna juxtaposed with one existing in time. Moreover, traditional iconography offers no clue for any representation of the Madonna of Divine Providence in such a form, showing her instead either as a half-figure in the lap of the Father or as a maiden standing surrounded by a certain number of symbols referring specifically to the *immaculata conceptio*. Pre-existence in divine providence—which in any case is not limited to the Madonna—is part of the theological basis for the Immaculate Conception of Mary. Yet it is precisely the symbols indispensable to that context which are missing from the central picture. Moreover, most of Bridget's metaphors involving light do not refer to the pre-existent Madonna, and not a single one is really applicable unequivocally to the highly exceptional figure Grünewald painted here.

By adducing so many completely generalized metaphors for light—and thereby turning everything into pure poetry—the controversial figure is relegated to a sphere of wholly indefinite subjectivity, which ends up by having nothing to do with the theological content. For Grünewald, light is no mere poetic metaphor. He clearly emphasizes Transfiguration as a particular state of the Madonna, in the same way as he distinguishes the risen Christ from the crucified Christ by the Transfiguration undergone by the former.

For the Madonna in the landscape at the right, both Feurstein and Zülch propose passages from Bridget's text that describe Mary as a "rose among thorns" for the reason that "in her foreknowledge of the Passion and glory of Christ she was the most joyful and the most sorrowful of mothers." During the conception, then during the time of waiting, finally "each time she wrapped the Child in His swaddling clothes" and "as often as the Virgin gently wound the bands around her infant's arms and feet" and "let her eyes rest on the Child's countenance," she comprehended clearly all the martyrdom that Christ was destined to endure in His body. One passage does express this foreknowledge in its true essence, as mystical contemplation: "Just as the blessed Virgin was more full of joy than all other mothers each time she gazed on her newborn Child, in that she knew Him to be truly God and truly Man, mortal in His earthly frame, immortal to all eternity in His divinity, so was she in her foreknowledge of his most bitter sufferings at the same time the most grieved of all mothers." Here we seem to have a direct expression of the wonderfully profound absorption of the Mother in contemplation of her Child as rendered by Grünewald. Likewise the torn swaddling clothes can be taken as an allusion to the suffering that lies ahead. Despite all this, this passage suffices to clarify only the single motif but not the entire figure, the paraphernalia of the lying-in room, the *hortus conclusus*, or the landscape with the tidings brought to the shepherds.

Since the overall pictorial idea of the Madonna in the landscape is not to be found in Bridget's writings, Feurstein and Zülch try to explain it on general grounds, arguing that here Grünewald took over from Dürer the motif of the Madonna in a landscape. True enough, the Madonna in the closed garden set before an open landscape had been a favorite theme in German graphic art ever since the Master E. S. and Schongauer, and only Dürer's compositions are more closely related to Grünewald's than theirs. Grünewald does in fact use the accepted scheme of the Madonna and Child in the closed garden in front of a landscape where one sees the annunciation to the shepherds in the background and, in the sky, the apparition of God the Father, much as in Dürer's *Virgin with the Dragonfly* or *Madonna with Several Animals*. In an attempt to bolster up his argument, Feurstein demonstrates that certain formal elements were borrowed by Grünewald directly from Dürer. But even if one accepts this, these are influences affecting form alone and signify no more than that a motif has been borrowed by one artist from the other. Nor does this in any way alleviate the problems that have to do with the inner meaning of a motif. At most it displaces the whole question into the realm of traditional iconography where it becomes merely a matter of the generalized theme of the Madonna in a landscape.

The *hortus conclusus* can appear in very diverse contexts. If seen as a unity with the landscape, there can be no doubt that it represents, in essence, Paradise. The landscape behind the Madonna is therefore the New Paradise, the Eden regained through the coming of Christ. The development of that idea can be traced through a long series of examples. But this is at best a generalized notion and tells us nothing about the special landscape Grünewald sets before us, a landscape containing such a unique assemblage of symbols and figurations that one has no choice but to assume that it has a very special meaning. In general, the attempt to link up Grünewald's picture with Dürer's Madonnas in a landscape ends up with no more than the same notion of a paradisiac realm of peace as already proposed by Joseph Bernhart.

76 Von Einem, "Die 'Menschwerdung Christi'. . ."

After a detailed comparison with similar representations in the visual arts, Von Einem opts for a precise significance for the small Madonna under the baldachin: "The kneeling figure in long dress and hanging hair, with hands clasped in prayer, is Mary as a temple virgin before her betrothal to Joseph. The edifice is the temple in Jerusalem. To it belong the prophets on the pillars and the patriarchs on the tympanum. The angels are servitors." This is, accordingly, merely the familiar scene from the apocryphal gospels utilized originally as a point of departure for purely theological

interpretations also. However, Von Einem proposes a connection between the small Madonna and a specific figurative type as represented by a reputedly wonder-working image of Mary as a temple virgin, which is in the cathedral in Milan. This highly venerated and therefore often copied votive image—donated to the cathedral by Germans—was originally a silver statue, then transformed into a picture, and still later once again into a statue. It shows the youthful Mary in prayer facing the viewer, in a "long, girdled gown with a pattern of ears of wheat, her hair falling loosely to a flame-shaped collar." In many paintings, this youthful figure with clasped hands is shown in a church interior, either standing or kneeling before an altar and praying or reading from a book, while in the background and above her are the angels who attend her. Since the Old Testament prophets and kings—Moses and David—are depicted on the altar tabernacle, there can be no doubt that what we are seeing is meant to be the interior of the Temple of Solomon.

Thus Grünewald's small Madonna in the minuscule gold temple would be based on the pictorial type of the Virgin in the Temple of Solomon. To connect this scene with the Madonna and Child, Von Einem proposes passages from various late-medieval legends such as the words "Scripturas de adventu Christi frequenter legebat . . ." in the *Liber de Vita Jesu Christi* by Ludolph of Saxony or "Virgo . . . ab angelis quotidie visitabatur et visione divina quotidie fruebatur" in the *Legenda Aurea*. We are told that "here it becomes clear how the relationship of the kneeling Madonna to the group on the right must be read," meaning apparently that what we have there is the temple Virgin's vision of the birth of Christ. To be sure, in Von Einem's conception, which is shared by many other writers, Grünewald's Virgin in the Temple is shown already "blessed in the womb." But for this he seems to seek further clarification from similar notions to be found in texts of Byzantine provenance which celebrate Mary's sojourn in the Temple as occurring after her betrothal.

According to an apocryphal gospel of Eastern provenance, the Protoevangelium of James, VII–VIII, at the age of three, Mary was escorted to the Temple by a bridal procession with burning torches, to live there where angels nourished and instructed her. In accord with the notion promulgated as early as Augustine that the act of the conception of Christ was at the same time an act of mystical contemplation, in late-medieval Marian legends in the East as well as the West the education afforded Mary in the Temple is thought of as instruction in contemplative prayer accompanied by the appropriate visions. This then would be the period of preparation for the contemplation of the passage from Isaiah during which the Annunciation—that is, the conception—took place. As we noted, in the *Annunciation* Grünewald shows this text in the versicle form in which it appears in the Breviary in order to characterize Mary even more clearly as advocate of the contemplative life. But in that case he would have had to place the end of the preparatory period, the Annunciation, at the beginning, if the temple Virgin is depicted with her womb already "blessed." Once again, then, as in other attempts at interpretation, she would become a Mary in *exspectatio partus*. However, such a dubious inversion of the meaning of the legend would scarcely be necessary. It is by no means certain—and the whole notion has been challenged repeatedly—that Grünewald intended to portray Mary as pregnant here. She is enveloped in a broad ceremonial mantle which she gathers up high in front and holds with arms tightly pressed against her body in the usual fashion of the time. In such depictions there results as a rule an additional puffing up of the garment which in many cases, even where—as in Assumptions—it quite certainly could not have been so intended, must have been taken to represent pregnancy.

Meanwhile, however, the real difficulties in the way of interpreting the small Mary as a temple Virgin do not lie there but, instead, in the other motifs Grünewald introduced: in the unusual exotic form of the temple, in the transfiguring nimbus, and in the double-coronation with the fiery crown and the imperial crown and scepter held above it. In any wide-ranging attempt at logical interpretation these too demand explanation. For Von Einem the coronation with flames is no more than Grünewald's arbitrary transformation of a motif: "In place of the collar of flames we have in Grünewald the crown of flames."

As for the other motifs, Von Einem believes that a basis for them can be found in the general development of the theme of the Virgin in the Temple. In the fifteenth century, in allegorical depictions of the *immaculata conceptio*, the temple Virgin is depicted full-length but without the background of an interior, domestic or ecclesiastical. That image taken in and for itself became a devotional picture of the special virginal purity of Mary from her childhood on. To express the idea that Mary was uncontaminated by original sin, she was shown as a temple Virgin surrounded by an ensemble of fifteen motifs, all of which have a direct reference to her. Certain of those motifs—the *hortus conclusus, plantatio rosae, porta coeli*, for example—are always directly related to her virginity preserved within her maternity. Taken as a whole they signify the absolute immaculateness of the Madonna. In the sixteenth century this ensemble of motifs was transformed into a single unified landscape, and then the principal figure, the Madonna in the center of the picture, was elevated to the upper area where she was depicted as soaring in the sky. At the same time a fusion with the iconographical type of the apocalyptic Bride of the Sun took place, from which the Madonna acquired the nimbus of sunlight and the crown borne above her head by angels. She thereby became also the Madonna of Divine Providence, the wisdom created before the Fall of Man, the vaster allegory of the Madonna as a participant in the work of Redemption.

In any event, if one accepts Von Einem's interpretation, then in the final analysis the small Madonna ends up as a completely generalized image expressive only of her essence as Madonna and with at best only a symbolic relationship to the Temple of Solomon.

77 The Lerse manuscript is reproduced in H. A. Schmid, *Die Gemälde . . .* , p. 198.

78 *Ibid.;* this is how Lerse describes the *Meeting of Anthony and Paul:* "In a landscape which is well-chosen and masterfully colored after Nature, composed of two moss-covered cliffs set to either side and between which one sees a distant view and a few half-bare trees grown over with moss and other vegetation, giving the perfect semblance of a desert [*Wüste*]. . . ." Below this there is a correction, "deep solitude [*tiefen Einsamkeit*] but no desert," which obviously corrects the expression "desert" used by the guide, a religious no doubt, who showed him the altarpiece.

79 *Ibid.*, p. 87.

80 Lanckorońska, *Matthäus Gotthart Neithart*, p. 141, relates the beads to the Rosary of the Joys of Mary.

81 Beissel, *Geschichte der Verehrung Marias . . .* , p. 114.

82 Translation after *Die Reden des Hl. Bernhard über das Hohe Lied*, I, trans. into German by V. Fernbacher (1919), p. 179, the allocution on the Nativity of the Lord.

83 Although all the components of the iconographic type of the Madonna in a paradise landscape are found in Grünewald's picture, the way certain specific motifs are represented is wholly unconventional. The apparition of the Trinity above the landscape is not only rendered as a vision composed of light but also as a kind of cloudscape with an entire scenery of heavenly spirits. From the figure of the Lord enthroned there descends a procession of transpar-

ent creatures of light under a baldachin, a kind of Corpus Christi procession. Thus the Incarnation of Christ is depicted quite literally as a descent of Christ to earth, a scene not found in traditional iconography but in such literary sources as the writings of Hermann von Fritzlar.

84 For the wine jug, see Münzel, "Eine neue Erklärung . . . ," pp. 75 ff.

85 For the washing and putting to bed as a mystic exercise, see Muschg, *Die Mystik . . .* , pp. 100, 297.

86 E. Knoth, *Ubertino da Casale* (Marburg, 1903), p. 11.
 H. Schrade, *Die Franzlegende* (Cologne, 1967).

87 Augustine, *Opera*, in Migne, *Patrol. Prima*, 39, 2205.

88 *Vita B. Antonii*, chap. 3.

89 In the preamble to the Rule of Saint Benedict.

90 A clear source is Dante's description in the *Paradiso* of a monastic landscape on Saturn, the planet of anchorites and founders of Orders. In Dante's still medieval conception, Saturn presides over the Golden Age and its Christian counterpart, the *vita contemplativa*. From Saturn, the most remote of the planets known to Dante's time, a golden ladder of light rays climbs to the Heaven of light, the Empyrean, for Saturn is considered the instigator of the spiritual vision of God. The Heaven of Saturn is accordingly the "soul's home" of the great exponents of the *vita contemplativa*, the holy anchorites and the founders of holy Orders. True, in Dante's scheme their souls are found in the Empyrean as one would expect, directly in the eye of God, but the special "*forma*" of their terrestrial destiny—an existence completely bound up in monastic contemplation—still has its home on the ruling planet Saturn. For that reason, when two exponents of the contemplative life, Saint Peter Damian and Saint Benedict of Nursia, appear before Dante's eyes on Saturn, it is in association with that planet that they conjure up a picture of their earthly home, the anchorites' mountainous landscape with the monastery as the seat of the *vita contemplativa*. Here we have the visual image Dante presents of these visions. First the Heaven of Saturn and the ladder of light rays (*Paradiso*, XXI):

> Within that crystal, to the name still wed 25
> Of its belovèd regent [Saturn] 'neath whose might
> All evil in the world it rings lay dead,
> Coloured like gold which flashes back the light, 28
> I saw a ladder raised aloft so far
> It soared beyond the compass of my sight.
> Thereon I saw descend from bar to bar 31
> Splendours so numerous I thought the sky
> Had poured from heaven the light of every star.
>
> . . .
>
> One splendour [Peter Damian], which the nearest to us drew, 43
> So brilliant showed itself, my thought was then:
> "Plainly the signal of thy love I view. . . ."

In the course of the ensuing dialogue, Peter Damian gives a picture of the anchoritic landscape (*Paradiso*, XXI):

> Before the bourne his words prescribe I bow; 103
> Myself withdraw and let my question [concerning the mystery
> of predestination] lie.
> Humbly I ask him: "Tell me, who art thou?"
> "'Twixt two Italian shores are lifted high 106
> Tall crags, and near thy home so far they rise
> The thunder peals below them distantly.
> And where they shape their skyline humpback-wise 109
> Is Catria; below, a hermitage,
> Once to God's service consecrated, lies."

> These details did the opening words presage 112
> Of his third discourse; now the rest I give.
> "There, ever constant in God's vassalage,
> Through heat and cold serenely did I live 115
> On meagre food, seasoned with olive-oil,
> Dwelling content in thoughts contèmplative.
> Our cloister yielded from its fertile soil 118
> Souls to these heavens; but now 'tis sterile grown.
> Soon will men see what sins its fruit despoil.
> Therein as Peter Damian I was known. . . . 121

Subsequently, Saint Benedict appears on Saturn and tells of the first monastery (*Paradiso*, XXII):

> Moving towards me, from those pearls there came 28
> The largest and most lucent, to fulfil
> My silent longing to enquire its name.
> From deep within it, this was audible: 31
> "If thou, as I, our burning love didst know,
> Thy inmost thoughts would be expressible.
> But, lest by tarrying thou shouldst prove slow 34
> To reach thy lofty goal, I will reply
> Before thou ask, to what concerns thee so.
> Cassino on a spur of hill doth lie, 37
> About whose summit, once, there dwelt a herd
> Of people pagan and perverse. There I,
> The first, bore up the tidings of the Word 40
> Which came on earth that truth might be revealed
> And power to rise above on man conferred.
> Such was the grace illuminating me 43
> That I reclaimed the neighbouring villages
> From wrongful worship and impiety.
> These other flames were all contèmplatives, 46
> Warmed by the sun that kindles bounteously
> The flowers and the fruits of holiness. . . ."

The verbal picture Dante gives here is very much like what we find in the background landscape on the right side of Grünewald's problematic scene: a high mountainous place with a monastery on its slope. Dante clearly had in mind a particular place or he would not have mentioned a mountain and a monastery twice. True, the mountainous landscapes with monasteries are described by Peter Damian and Benedict as the scenes of their earthly existence, but it is plain to read in Benedict's words that he equates the ladder of light rays rising from the monastery with the similar ladder that leads up from Saturn to the Empyrean (see XXII, 68–72). Dante deliberately associates a particular setting with Saturn: the paradisiac landscape of the anchorites' existence with the mountain of the house of the Lord in the background, and this is the way the Middle Ages envisaged the same landscape that plays such a significant part in the *Vita B. Antonii* as well as on the two wings having to do directly with Anthony on the innermost position of Grünewald's altarpiece.

91 P. Schubring, *Illustrationen zu Dantes Göttlicher Komödie* (Zurich, 1931), fig. 241.

92 Zülch, *Der historische Grünewald*, p. 143.

93 J. Walter, "Der deutsche Malerfürst Matthias Grünewald," *Christliche Kunst* (1918–19), pp. 73 ff.

94 A. Feigel, "Christus Triumphator," *Hochland*, XVI (1919), 22.

95 Feurstein, *Matthias Grünewald*, p. 87.

96 Zülch, *Der historische Grünewald*, p. 143.

97 Feurstein, *Matthias Grünewald*, p. 86, quotes from the *Revelations* of Saint Bridget, Book IV, chap. 70: "The crown of thorns was pressed down firmly on his head, it hung halfway over the face. The blood that gushed forth from the pricking of the thorns ran down in countless streams over the face and filled eyes, hair, and beard so that the whole looked to be almost no more than a river of blood. . . . The half-closed eyes were cast down and the already dead body hung slack. The knees were bent to one side, the feet twisted to the opposite side as if the nails driven through them were door hinges." What we have here is therefore unquestionably a crucifix in which the body hangs down with knees pulled to one side.

98 E. M. Vetter, "Die Kreuzigungstafel des Isenheimer Altars," *Sitzungsberichte der Heidelberger Akademie der Wissenschaften, Phil. hist. Kl. Jhg. 1968*, Abhandlung 2 (Heidelberg, 1968). This essay came to my attention only after completing the present manuscript. It too casts doubt on the pertinence of the text from Bridget.

99 Quoted from Bonaventura, *Das vollkommene Leben*, trans. into German by T. Gerster (1936), chap. 6:5.

100 G. Seewald, "Die Marienklage im mittellateinischen Schrifttum" (dissertation; Hamburg, 1952).
E. Wechsler, *Die romanischen Marienklagen* (Halle am Saale, 1893).
Theo Meier, *Die Gestalt Marias* (Berlin, 1959).

101 Meier, *Die Gestalt Marias*, p. 151.

102 Heinrich Seuse [Suso], *Deutsche Schriften*, ed. K. Bihlmeyer (Stuttgart, 1907).

103 Concerning Mary as exponent of the *vita contemplativa*, see Jerome (*Adversus Helvidium*, pp. 18 ff.), Gregory of Nyssa (*In Christi res. or.* 2), Ambrose (*Epist.* 63, 33), Augustine (*De bono conjug.* and *De s. virg.*), and *Sicardi Cremonensis Episc. Mitrale.* in Migne, *Patrol. Lat.*, 213, pp. 60 ff.: "cum his Mater virgo depingitur, quae fuit utriusque vitae magistra, activae, quia nupta, contemplativae, quia contemptibilibus indumentis induta."

104 Karl Sohm, *Der Isenheimer Altar* (Bamberg, n. d. [1957]), pp. 7 ff.

105 Quoted from Bernard of Clairvaux, trans. by Fernbacher, 1919.

106 Vetter, "Die Kreuzigungstafel . . . ," pp. 12 ff., gives a detailed treatment of the various aspects of the concept of the increase of God. It seems to me dubious, however, to put so much emphasis on the astronomical and general viewpoints of the ontic theory of light without taking into account the intensifid portrayal of suffering. The homily of Bernard of Clairvaux which I have quoted, but which is not mentioned by Vetter, seems to me to characterize more clearly the particular intention that was aimed at.

107 Sohm, *Der Isenheimer Altar*, p. 8.

Index